Road Show

ART CARS

and the museum of

THE STREETS

Eric Dregni and Ruthann Godollei

speck press

golden

Published by Speck Press
An imprint of Fulcrum Publishing
4690 Table Mountain Drive, Suite 100 • Golden, Colorado 80403
303-277-1623 • speckpress.com

ISBN-13: 978-1-933108-17-9

Library of Congress Cataloging-in-Publication Data
Dregni, Eric, 1968-
 Road show : art cars and the museum of the streets / by Eric Dregni &
Ruthann Godollei.
 p. cm.
 Includes bibliographical references and index.
 ISBN 978-1-933108-17-9 (hardcover)
1. Automobiles–Decoration. 2. Folk art. I. Godollei, Ruthann. II.
Title.
 TL255.2.D74 2009
 629.222–dc22
 2008042057

Printed and bound in China

 10 9 8 7 6 5 4 3 2 1

Book layout and design by Margaret McCullough

Cover image: © Corbis, photographer Al Satterwhite
Cover inset image: Erwin Wurm, *Fat Convertible*, photograph © Magarita Haruspex,
Courtesy MCA Gallery, Artist Courtesy of Galerie Krinzinger and Galerie Xavier Hufkens
Back cover image: Snail's Pace © Jon Sarriugarte

ACKNOWLEDGMENTS

The Art Car Museum of Houston, the Louwman Collection, Harrod Blank, Allen Christian, Circus World, Sonia Delaunay for pioneering the modern concept, Jan Elftmann, Jenski, Intermedia Arts, International Bowling Hall of Fame and Museum in St. Louis for housing the bowling pin car, the Minneapolis Institute of Arts, which has a surprising number of vehicle-themed objects, Derek Lawrence at Speck Press for believing in art cars, Macalester College for tolerating a creative parking lot, MARV (aka the art car artists of Minnesota), who walk on water when the lakes freeze, Michel McCall for teaching that culture is cooked, Nick Hook for his anti-art *Hopper Mobile* toilet car, Katy McCarthy for all her patience while we worked, Big Big Erika Nelson, Dean and Patty Raeker, Craig Upright for copiloting, Vinnie & the Stardüsters, Juanita, K. K., Z. Z., and Tom Wolfe for believing that customized cars are indeed works of art.

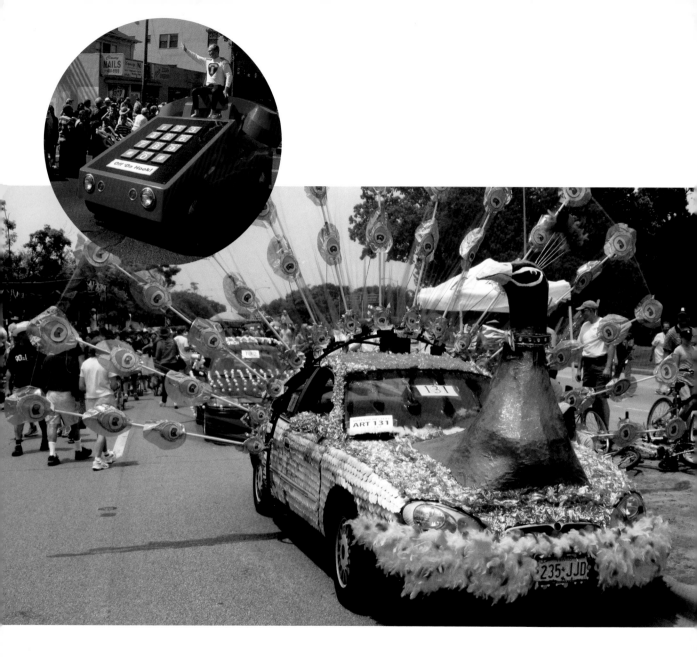

Telephone Car (inset)
By Howard Davis. *Courtesy of Harrod Blank*

Percy Peacock
By Sam Jones. *Courtesy of Nick DiFonzo*

Contents:

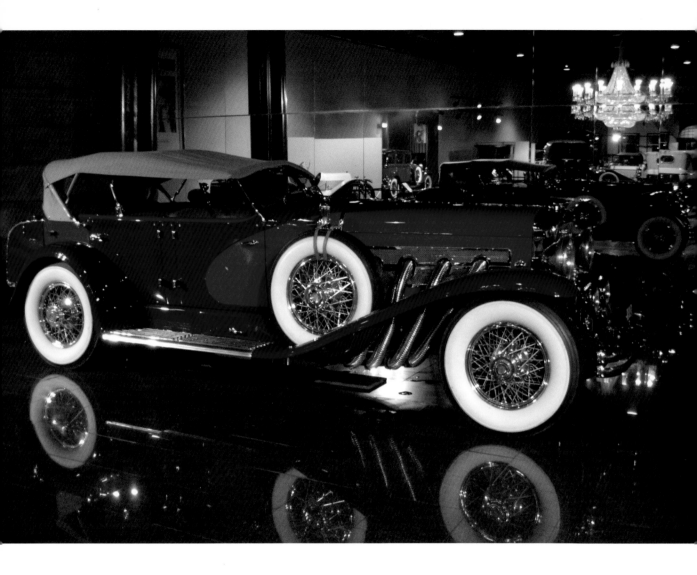

Duesenberg, SJ LaGrande Dual-Cowl Phaeton, 1935
Only thirty-six supercharged SJs were built,
intended as the "world's best automobile…as
beautiful as it is powerful" by its maker, Errett
Lobban Cord. *Courtesy of the Louwman Collection*

Ford, Model A, 1903 (inset, opposite page)
The first Ford horseless carriage looks spiffy
compared to contemporary assembly-line
cars, until you see the handcrafted wonders
it replaced. *Courtesy of the Louwman Collection*

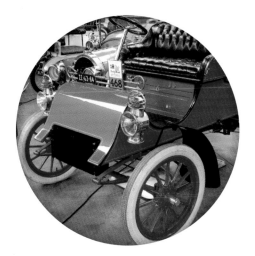

REVOLT AGAINST A "CAR FOR THE MASSES"

In the past 100 years, nothing has changed our world more than the automobile. "The motor has killed the great city. The motor must save the great city!" Swiss designer Le Corbusier declared in 1925. He hated the narrow, confining streets of Paris and extolled the wide boulevard of the Champs-Élysées as the "glory of Paris today and the only avenue which renders real service to motor traffic." (Never mind that the Champs-Élysées was made by Napoleon to better show off his military might during marches to the Arc de Triomphe.)

American capitalist Henry Ford agreed, announcing, "We shall solve the problems of the city by leaving the city." Architect Frank Lloyd Wright simply wanted to bulldoze Chicago to make wide avenues lined with mile-high skyscrapers. In spite of these antiurban attitudes in favor of cars, the automobile did relieve cities of mounds of horse dung—only to pump out sooty exhaust and help create a new word: smog.

"I'm going to build a car for the masses," announced Henry Ford in 1903. Five years later, the Model T (aka "the universal car" or "Tin Lizzy") changed the face of America. Ford rarely advertised, since the Ts sold faster than Ford's company could make them; he relied on word of mouth and publicity through newspaper articles. Henry Ford was probably the most famous person of his time, and Theodore Roosevelt complained that Ford got more publicity than he did as the president of

Maserati, 3500 GT Touring, 1960
Maseratis are sculpture on wheels, automobile architecture to park in the driveway and make the neighbors stew with envy at the thought of driving such a tour de force. Here a Maserati 3500 GT Touring from 1960 was rolled onto the carpet in a Modena piazza.

Stanguellini, Junior Delfino, 1962
Among the hand-built classics from Modena are the Stanguellini race cars that drew skilled mechanics and designers from the area to create some of the fastest and most stylish artistic automobiles.

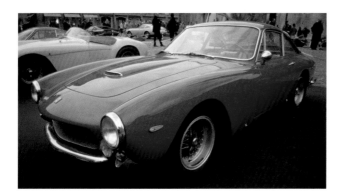

Ferrari, 250 GT/L, 1964
Enzo Ferrari rejected the American model of ever-more-mechanized assembly that replaced skilled workers. His factory in Maranello can only produce a limited number of these handmade cars, which increases the value and attention to detail by the loyal mechanics and designers.

the United States. To many, Ford was a great equalizer, but to *The New York Times* in 1928, he was "an industrial fascist—the Mussolini of Detroit."

Henry Ford tried to put his Tin Lizzy within the financial reach of everyone working in America. The more cars Ford produced year after year, the less expensive they became, which seems impossible by today's standards. Customers generally didn't want handcrafted objects, and this was one of the reasons Ford's cookie-cutter assembly line was so successful. The probably apocryphal statement by Ford that, "Any customer can have a car painted any color that he wants so long as it is black" speaks volumes about his modernist ideal regarding mass production of identical products. The problem was just that: enforced conformity.

The Model T actually did come in different colors, but the public began to long for even more individuality once city streets became clogged with these matching cars. Years later, Andy Warhol professed, "What's great about this country is that America started the tradition where the richest consumers buy essentially the same things as the poorest. You can be watching TV and see Coca-Cola, and you can know that the president drinks Coke, Liz Taylor drinks Coke, and, just think, you can drink Coke too. A Coke is a Coke, and no amount of money can get you a better Coke than the one the bum on the corner is drinking. All the Cokes are the same and all the Cokes are good. Liz Taylor knows it, the president knows it, the bum knows it, and you know it."

Still, consumers didn't want to look the same as everyone else in their automobile; they itched to make the Joneses green with envy. At the same time, the auto industry churned out thousands of similar cars, and only a few manufacturers followed their artistic vision by crafting "handmade" automobiles.

While modern art was echoing the production line of automobiles, certain companies bucked the trend.

Ferrari of Italy and Aston Martin of England touted their mechanics as artists who handcrafted their automobiles rather than using giant, impersonal robots like Detroit's big three. The Italian designer Pininfarina boasted that its design facility in Grugliasco was a "sculpture factory."

More and more, automobiles came to be designed by teams who watered down the original vision, and one of the last mass-produced cars envisioned by a single designer was the Volkswagen Golf in the 1980s. The far-out, jet-pod styling of designers like Harley Earl in the 1950s had disappeared, and ironically the best place to see these classic American land yachts is in Cuba. (Under the hood, these rust-free cars have been jerry-rigged to keep the engines running, since spare parts can't sneak by the embargo on Cuba.)

Ford tried to appease the public's desire for individuality by offering its customers the choice of engine, shape of the body, color of paint, and trim level on its 1960s Mustang and Capri models to total more than 900 different combinations.

As the factory-made auto took to the fore, beautifully designed handmade cars from the past became nostalgic objects to marvel at, lust after, or collect (for example, the very wealthy). The idea that one might still handmake a vehicle today is surprising to most people. That such a vehicle might take any shape one desires provokes astonishment. For example, art car artist David Crow paired the drooling devotion associated with the shiny red hotrod with his girlfriend's love of fashion footwear in a one-of-a-kind motorized homage to fetishism, *The Red Stiletto*. A 1972 Honda CB350 motorcycle powers the sculpted bodywork.

Erwin Wurm, one of Austria's most famous contemporary artists, is known for creatively playing with expectations. He has spent more than twenty-five years redefining sculpture as a conceptual encounter between people and objects. His themes include the cult of consumerism

and the fetishization of the home and car, among others. Altering the form of automobiles in ironic and humorous pieces—such as his 2005 *Fat Convertible*, a grotesque, bloated parody of a sleek red Porsche—is one such artistic statement.

Aside from Ford's mass-production uniformity, designers traditionally worked with engineers to design cars as an expression of artistic vision and forward-looking fashion concepts. Imperatives of the market eventually meant large automobile firms lent designers less freedom to envision unique forms and applied pressure to conform styling to what was predicted by marketers to sell well. With enough money, anyone can buy an assembly-line car, making this product simply financial capital that deteriorates over time. Cultural capital comes from people participating and defining their tastes with their own creativity. Thus, art cars.

"The average man hardly cares for any living being with the intensity and persistence he shows for his automobile. The machine that is adored is no longer dead matter but becomes something like a human being."

—Herbert Marcuse, circa 1938

David Crow,
***The Red Stiletto,* 1998**
This art car artist paired his drooling devotion to the shiny red hotrod with his girlfriend's love of fashion footwear in a motorized homage to over-the-top fetishism.
Courtesy of the Art Car Museum

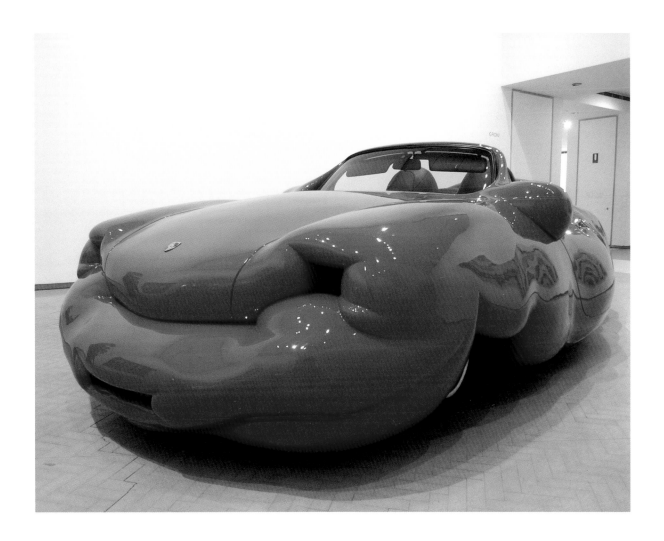

Erwin Wurm, *Fat Convertible*, 2005
The Austrian conceptual sculptor added rolls
of Styrofoam lard to this Porsche and painted
it lipstick red. Still shiny, but flabby, does the
sports car exude the same appeal? *Photo by
Magarita Haruspex, Courtesy MCA Gallery, Artist Courtesy
of Galerie Krinzinger and Galerie Xavier Hufkens*

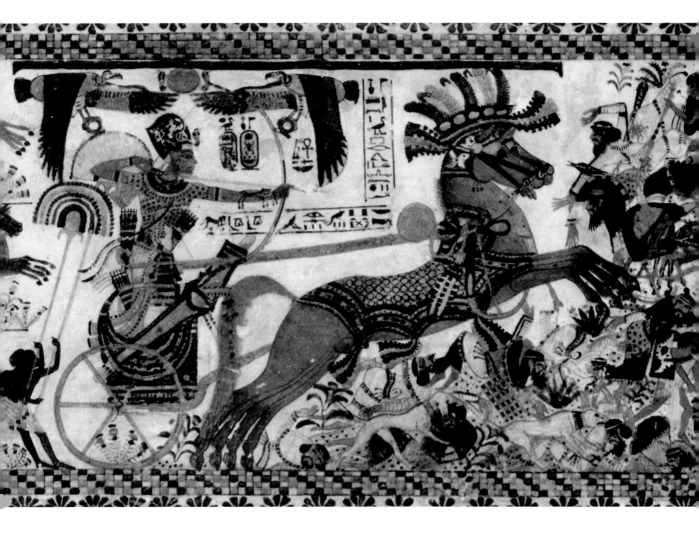

Painted Wooden Chest, circa 1327 BC
A casket depicts King Tut's decorated chariot in action as the pharaoh's horses trample over hapless enemies. Vultures, the symbol of Upper Egypt, protect the divine boy king, while servants fan him between arrow blasts.

King Tut's Golden Chariot, side panel, circa 1327 BC (inset, opposite page)
The chariot unearthed in Tutankhamen's tomb is covered in beaten gold, encrusted with semiprecious gems depicting scenes of conquest, hunting, and royal splendor. Since archaeologists know Tut was only a minor pharaoh, one can only imagine the magnificent rides of the greatest rulers of ancient Egypt.

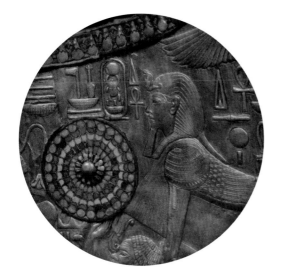

BIRTH OF THE ART CAR

The idea of art cars can be traced at least as far back as King Tut's chariot. But Tutankhameun was a minor boy king, and archaeologists tell us that Ramses the Great and some of his predecessors must have had far more spectacular conveyances. The chariot found in Tutankhameun's tomb of 1325 BC is covered in beaten gold, encrusted with semiprecious gems depicting scenes of hunting, conquest, and royal splendor, and tells us of the staggering magnitude of greatness the Egyptian rulers rolled around in during that time. Gold was called "the flesh of the gods." A golden chariot carrying a pharaoh, an incarnation of a god on Earth, reinforces the connection between the sun, traveling the sky with its glittering rays and life-giving force, and the shining ruler with mystical and physical powers. It must have been an awesome experience to see a pharaoh gliding past on golden wheels.

In many cultures, gods and goddesses are known to have ridden across the heavens. In classical mythology, Athena is credited with inventing the war chariot and is depicted on ancient Greek vases harnessing up her horses for wheeled battle.

A wooden Sumerian mosaic called *Battle Standard of Ur*, now in the British Museum in London, dates from 2600 BC and depicts four-wheeled chariots pulled by animals.

The Woman of Vix, a high-ranking Celtic female from the late sixth century BC, was found buried in France with her bejeweled body placed inside the bed of an elaborately

decorated openwork wooden cart with bronze and iron fittings. A reconstruction of the wagon can be found at the Museum für Antike Schiffahrt (Museum of Antique Shipping) in Mainz, Germany.

Similarly, in Oseberg, Norway, a Viking-age wagon from between AD 800 to 1050 was found inside a buried ship that housed the tomb site of two women, at least one of whom was likely very high ranking. The body of this four-wheeled oak vehicle was beautifully carved with figures depicting Viking legends. Included in the burial goods were lovely, rare tapestries in wool and silk with procession scenes of horses pulling decorated carts. These artifacts reside at the Viking Ship Museum in Oslo.

Rubbings from low-relief carvings on the walls of the Wu family shrine of second-century China show Eastern Han Dynasty nobility zipping about in processions of two-wheeled horse carts with elaborate canopies that could be removed to use as parasols. The mausoleum complex of Chinese Emperor Qin Shi Huang, circa 210 BC, famous for its life-size terra-cotta army that included 130 war chariots, also contained two sets of bronze chariots and horses for the first emperor's afterlife. Exquisite Chou Dynasty bronze axle caps have also been found in burials, indicating sumptuous carriages for the ancient Chinese well-to-do dating as far back as the late sixth to fifth century BC. One notable pair in the Minneapolis Institute of Arts is finely cast with animal motifs; ducks or geese form the linchpins and tiny dragon heads adorn each hubcap body.

Thus we know that wheeled vehicles mean more to their owners than simple transport. They connote status, power, autonomy, and have been used as a means of personal and artistic expression since their invention. The wealthy and powerful traditionally use opulent vehicles to put status on mobile display, literally parading it through the streets. Artists and skilled artisans were hired by rulers and elites to make stunning transportation to reinforce the importance of the owner who rides in style, feet never touching the ground.

Artist Albrecht Dürer designed a spectacular parade vehicle for Emperor Maximilian I in a woodcut print dated between 1518 and 1522, the triumphal cart decorated with carved dragons, lions, griffon, eagles, and a sun canopy. The wheels were inscribed *magnificence*, *honor*, *dignity*, and *glory*. Modern-day chrome spinning wheel rims have nothing on this dazzling display of hubcaps. The carriage came complete with dancing allegorical female escorts bearing wreaths and ringing bells, personifying twenty-two kingly virtues such as *liberalita*, *inteligentia*, and *providentia*. The cart is driven by a female incarnation of rationality or reason, holding the reins of nobility and power. The emperor died before his grand triumphal procession was ever held, so the printing blocks and design for this vehicle remained in Dürer's hands.

The first self-propelled automobile was Hans Hautsch's Triumphwagen from 1649, built in Nuremburg, Germany. It could reach 2,000 paces an hour, and the front was a sort of sea monster (as on Viking ships

Exquisite Axle Caps, circa fifth or sixth century bc
Modern spinning hubcaps can find their predecessors in these Chinese bronze axle caps. Tiny dragon heads adorn the hubcap body along with finely cast animal motifs, and ducks or geese serve as linchpins. *Courtesy of the Minneapolis Institute of Arts*

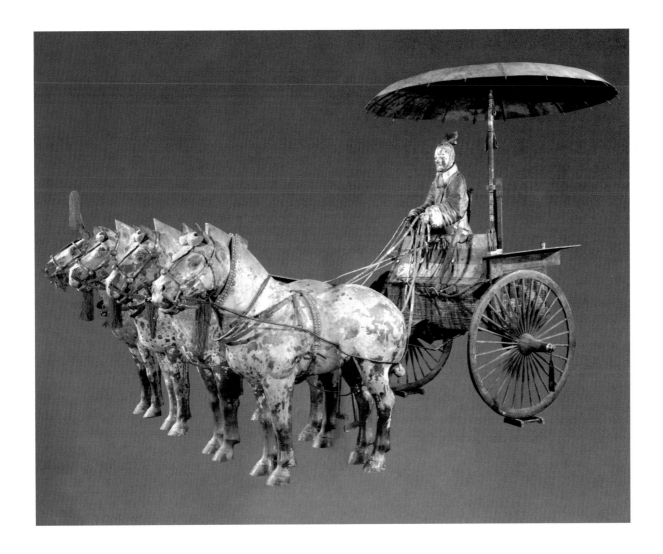

Bronze Chariot Fit for an Emperor, circa 210 BC

The mausoleum complex of the "First Emperor" Qin Shi Huang of China—famous for its life-size terra-cotta army—also contained two sets of model bronze chariots and horses for the emperor's tours in the afterlife. Gilding and tassels would have adorned the cabin of the regal conveyance on top of the exquisite brocade cloud, dragon, and phoenix patterns.

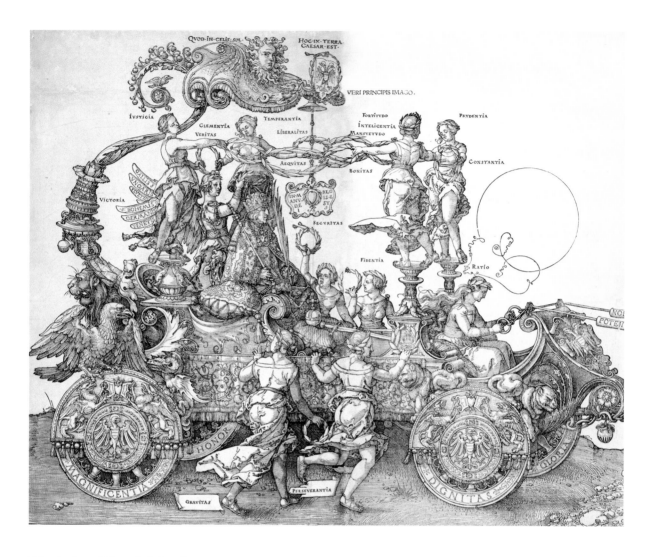

**Dürer's Great Triumphal Cart for
Emperor Maximilian I, circa 1518–1522**
Albrecht Dürer decorated a triumphal cart with carved dragons,
griffons, and a sun canopy in this woodcut print. He was
commissioned to design a parade vehicle for Emperor Maximilian I
of the Holy Roman Empire. *Courtesy of the Minneapolis Institute of Arts*

and Spanish galleons). Some claim the Triumphwagen was propelled by a sort of mechanical clock, since automatons were popular amusements for the Baroque-era wealthy. Others profess that a couple of men were trapped inside the machine, pumping away at pedals to move the giant mobile.

The Sun King, Louis XIV of France, had to have the most fabulous carriage of all. Having thrown courtiers in prison for building grander homes than his, riding in the most magnificent conveyance was more of a mandate than an afterthought. Strict rules of the French hierarchy dictated who would be allowed to ride in the royal carriage. This proceeded from rules about who might be allowed to sit at all in the presence of His or Her Majesty, for example. Queen Maria Theresa did not ride in a closed carriage but in an open one, for greater visibility by her adoring public.

Circuses and public spectacles often announced their entry into a new town with a parade of animals, clowns, and acrobats, drumming up business and creating excitement via a mobile preview of coming attractions. Circus wagons were often very elaborately decorated with gilded carvings and fanciful paintings exaggerating the ferocity of their wild beasts or the prowess of the performers. Gilding and carving on the wagons mimicked regal mobiles, as did the high boots, plumed hats, and tasseled uniforms of the drivers. Many circus acts claimed real or imagined ties to royalty. Performing for royalty gave an act cachet, and circus posters as well as wagons would proclaim the feat's special relationship to royalty. Purported princesses or kings with astounding powers arrived in gorgeous carriages from exotic-sounding far-off lands to reinforce concepts of foreignness and the coming extraordinary show.

Master carvers were employed in the nineteenth century to enhance circus wagon exteriors with illustrated fantasy figures in high relief. Wheels received special attention, and by the 1880s, circus-wagon makers added spades between the spokes. Painted in brightly contrasting patterns and colors, sunburst wheels had dazzling visual effects when in motion. Similarly, rotating rims are a contemporary custom addition to the flashy urban car in search of recognition. Art car artists today continue this tradition when they play with rotational graphic patterns on their wheel rims and hubcaps.

Parades can also denote a community's pride in its achievements, victory in war, or the restoration of peace. Holidays marking these events become occasions to commemorate, reenact, or display official propaganda or collective ideas about their significance, often through parades with floats and decorated vehicles.

Paper product manufacturers promoted premade bunting, streamers, and paper flowers to assist parade decorators in their arduous task of covering vehicles in festive adornments. Dennison Manufacturing Company (now merged with Avery) was founded in the 1840s by Aaron L. Dennison. By 1914 Dennison was manufacturing its own crepe paper, previously an expensive English import, and selling it in its own stores. Dennison published several craft booklets, including the pamphlet *How to Decorate Halls, Booths and Automobiles*, circa 1923. Dennison's brochure copy remarked, "The section of the parade which calls forth the most comment is the one of decorated automobiles. It may seem strange, but the first prize is more often awarded to the car decorated with pink, lavender or deep yellow than to those of any other color scheme."

In 1909 wealthy Englishman Robert Matthewson of Calcutta, India, commissioned a hand-carved, gilded wooden body for a Brooks steam car in the shape of a magnificent swan. Its superlatively opulent stylings sat somewhere between the circus and Raj royal pageantry. Details included eyes that lit up, an exhaust-powered, multitone horn, and the ability to spout steam from the bird's beak to clear the road of gawking peasants. In addition, it could spew whitewash from the

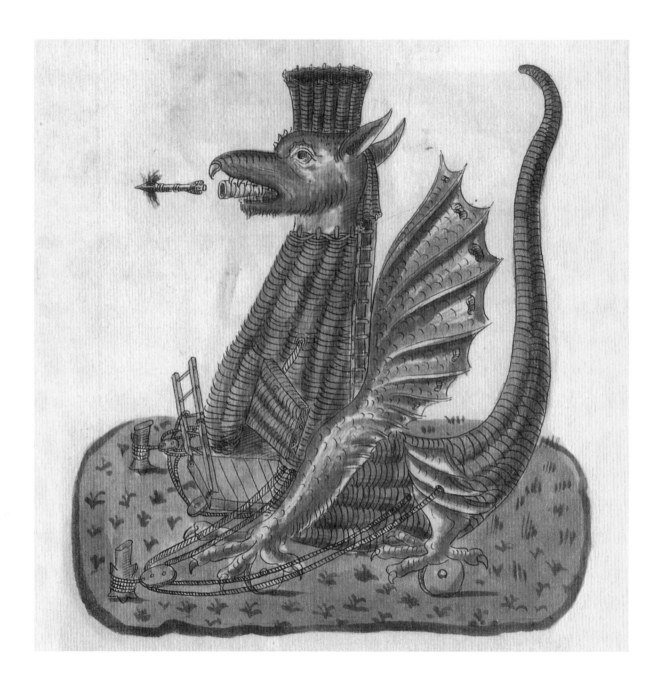

rear, in purposely obnoxious imitation of live swans. Matthewson spared no expense for the ability to drive his truly unique motorcar around Calcutta. According to the Louwman Collection, which now houses the singular vehicle, in 1910 the swan car cost "as much as six new Rolls-Royce Silver Ghosts!"

Architect Frank Lloyd Wright had some of his beloved cars (he owned Hillman Minxes, Cords, Duesenbergs, Austin Bantams, Crosleys, and more) custom painted Cherokee Red and Taliesin Red, his trademark colors. With himself in the lead in one of the big cars, Wright would make each of his apprentices drive the tiny Crosleys in an annual migratory parade between

Taliesin East and West. He chopped and customized the bodywork on a 1940 Lincoln Continental to remake it *architecturally.* Referring to the limitations of car design, he wrote:

> Here's the machine, here's quality now available, here are certain things that a new tool the world hadn't seen before could do very well—could do better than it could be done by hand...So first of all, the machine began imitating in architecture those things which had been done by hand. Well, they soon looked pretty dead and pretty tough and not worthy of a man's time or a second look. So someone had to devise ways and means of building whereby the machine could render even more beautifully than ever before the nature of the material, the nature of steel.

The urge to decorate, creatively alter, modify, and disguise mass-produced models came out of the push and pull between the stylings of early handmade vehicles and the somewhat pedestrian nature of later factory-made cars.

**Siege Machine,
drawn by Roberto Valturio, 1466** (opposite page)
The form of an implement of war could matter as much as its function in the early Renaissance. This wickerwork siege machine rolled up to an enemy castle in the guise of a fearsome dragon. *Courtesy of the Archivio Storico Torino*

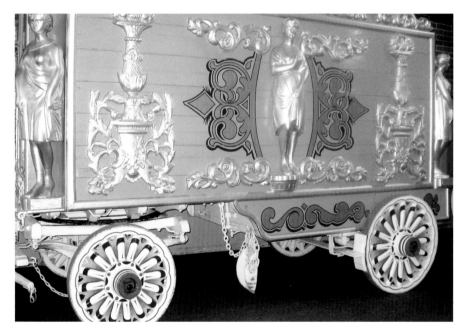

Beauty Tableau Number 89, circa 1890 (left) Barnum & Bailey and their competitors employed nineteenth-century master carvers to embellish circus wagon exteriors with illustrated fantasy figures in high relief. Beauties in states of semiundress were one of the lures of the show for a buttoned-up Victorian audience. *Courtesy of the Circus World Museum*

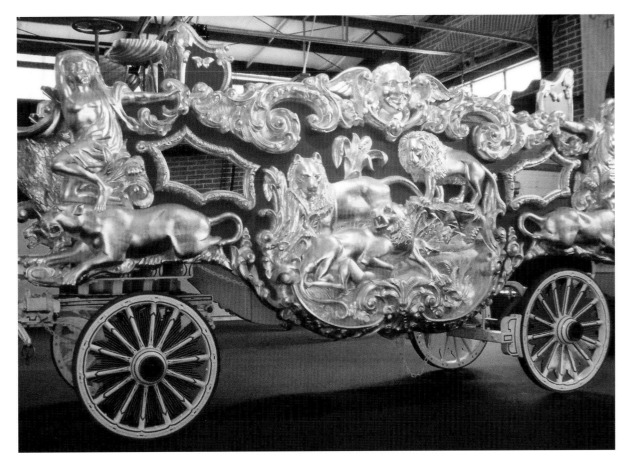

**Swan Bandwagon,
Moeller Company, 1905**
(above left, opposite page)
If the calliope and the
elephants didn't bring out
the crowds, this water
scene of nude nymphs and
muscular demigods could
convince adults to go see
the artistic show. *Courtesy
of the Circus World Museum*

**Wild Animal
Cage Wagon Wheel,
late nineteenth century**
(above right, opposite page)
Master craftsmen were employed
to enhance circus wagons from
the ground up. Even wheels on
the wild animal cage wagons
received special attention through
carving, gilding, and bright paint.
Courtesy of the Circus World Museum

**Lion and Mirror
Bandwagon No. 1,
1882** (above)
Fierce beasts fire up audiences
at traditional circuses. Originally
built for Adam Forepaugh, this
bandwagon with magnificent
gilded lions on the hunt became
the lead musical vehicle for
the Ringling Brothers Circus.
Courtesy of the Circus World Museum

Down with the Horse and Buggy!

Ever since humans put wheels under foot, a mirror was there to see how they looked. After all, motive for transport is not merely zooming from suburb to city, it's the appearance of absolute speed.

Most early cars looked like pokey wagons without the horse, thus the moniker *horseless carriages.* In 1899 the first streamlined car was produced, La Jamais Contente, with a sheet-metal body, little wheels for a low center of gravity, and an electric engine to boot. Designed in the shape of a torpedo by Belgian race-car driver Camille Jenatzy, this slick car set a land-speed record of a whopping sixty-six miles per hour. Jenatzy broke the 100 kilometers-per-hour record (about sixty-two miles per hour) driving past a sewage farm west of Paris, breaking the previous record by a Jeantaud electric car set by Count Gaston de Chasseloup-Laubat. Incidentally, designer Jeantaud committed suicide in 1907 when no one wanted electric cars anymore. And the intrepid designer of La Jamais Contente met his maker when he imitated a wild boar during a hunting party in France and one of the guests shot him.

In spite of the sorry fate of these first speed demons, they discarded the notion that the horseless carriage still had to look like a carriage. Most early automobile makers didn't readily learn this lesson—Henry Ford, for example—but Ferdinand Porsche took aerodynamics to heart as he tested the precursors to the VW Beetle for air resistance. The Chrysler Airflow of the same era preached 40 percent less air resistance than other cars of the same year, due to the unitized construction of the chassis and body.

The streamlining race was on as the lust to break the sound barrier grew. Filippo Tommaso Marinetti declared in his 1909 *Futurist Manifesto,* "We say that the world's magnificence has been enriched by a new beauty; the beauty of speed." Aldous Huxley agreed when he declared that the only new sensation of the twentieth century was speed.

Sixty years later, Jean Baudrillard echoed Marinetti and Huxley in his book *The System of Objects*:

> Movement alone is the basis of some sort of happiness, but the mechanical euphoria associated with speed is something else altogether, grounded for the imagination in the miracle of motion. Effortless mobility entails a kind of pleasure that is unrealistic, a kind of suspension of existence, a kind of absence of responsibility. The effect of speed's integration of space-time is to reduce the world to two-dimensionality, to an image, stripping away its relief and its historicity and in a way ushering one into a state of sublime immobility and contemplation.

While streamline moderne may have been the rage in the design of everything from coffeemakers to dining-car diners to automobiles, this look of modernity didn't necessarily mean that things moved or were made more quickly. A Franklin Auto ad of 1929 touted the "airplane feel" when riding in their vehicle. There was a vast difference between aerodynamics and streamlining. Even so, this didn't stop General Motors' Harley Earl from forming a styling department to appeal to the public's lust for modernity.

Earl designed the first mass-produced stylized car: the 1927 La Salle, complete with "flying wing" fenders. For smoother lines in the design, he used modeling clay rather than traditional wood and metal. Only after World War II would he go whole hog and base Cadillac design on the Lockheed P-38 twin-engine fighter plane. Chrysler and Ford had to follow Earl's lead to stay in business. The plane race was on as the 1949 Buick added venti-ports (mouseholes) to its side; the 1950 Studebaker Champion DXL countered with a pointed-nose hood and grille cloned from the fronts of planes. The impractical 1954 prototype

Firebird I, designed by Earl's GM team, was more jet-on-wheels than automobile, but it caught the public imagination. Chrysler made an aerodynamic-looking experimental prototype called the Predicta in 1957. Its predecessor, the 1956 Studebaker-Packard Predictor, was built in ninety days for the Chicago Auto Show and even had twin cockpits for passenger and driver. Unfortunately for Studebaker, they missed another key design cue of the era: chrome. The lack of the brilliant metal was likely one of the factors contributing to the car's demise.

By the early fifties, styling became more important than actual mechanical breakthroughs. As GM president Alfred Sloan said, "The policy...was valid if our cars were at least equal in design to the best of our competitors in a grade, so that it was not necessary to lead in design or to run the risk of untried experiments." John DeLorean, a GM exec, would later mourn that customers only bought cars based on styling, or "the new wrinkles in the sheet metal," and that there were no important technological innovations since automatic transmission and power steering. Once again, form won over function.

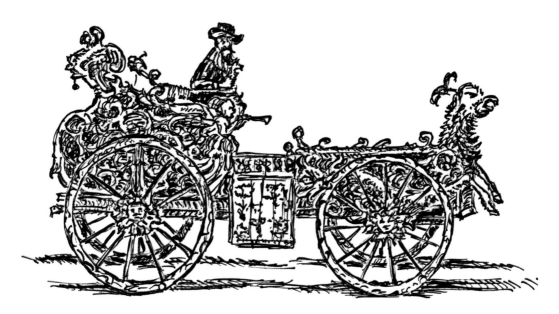

Triumphwagen of Hans Hautsch, 1649
The first self-propelled automobile was supposedly Hans Hautsch's Triumphwagen from 1649, built in Nuremburg, Germany. It could reach 2,000 paces per hour, and the elaborate design, with a prow like a Viking-ship sea monster, would strike terror into pedestrians. Hautsch, a talented mechanic, was also credited with inventing the first fire pump. *Drawing by R. Nadir, courtesy of a private collection*

Auto as Fashion Accessory

In the early twentieth century, individual artists began breaking boundaries, creating "new forms for our new sensations," as Virginia Woolf put it. This included looking to cars as canvases and, literally, vehicles for expression. French painter Sonia Terk Delaunay started a fashion design business in Paris to support herself and her husband, Robert, also a painter. Together, Sonia and Robert ascribed to their own type of cubism, which they titled orphism. This style found its way not only into Sonia's fashion designs, such as the simultaneous dress, but also onto her car. She is seen in a 1925 photo with two models and her painted Citroën B12, posed outside Robert Mallet-Stevens's Pavillon du Tourisme in Paris. Her roots in the prank-prone Dada movement may have encouraged her to put her art in what at the time was a completely strange context, the street, and in an odd

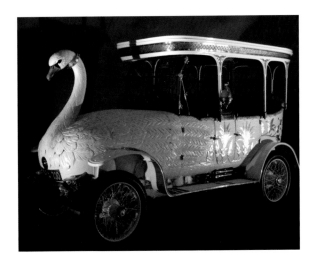

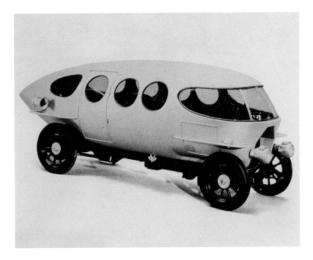

Brooks Swan Car, 1910
Wealthy Englishman Robert Matthewson of Calcutta, India, commissioned a hand-carved, gilded wooden body for a Brooks steam car in the shape of a magnificent swan. Details included eyes that lit up, an exhaust-powered, multitone horn, and the ability to spout steam from the bird's beak to clear the road of gawking peasants. It could even spew whitewash from the rear, in purposely obnoxious imitation of live swans. *Courtesy of the Louwman Collection*

Aerodynamic Coachwork by Alfa Romeo, 1913
With zooming automobiles topping twenty-five miles per hour on bumpy back roads, the public wanted a taste of the automotive future. Castagna Coachbuilders and Alfa Romeo came up with this aerodynamic future mobile in 1913, the same year *Scientific American* featured a nearly identical torpedo-style "Future-Car." Buckminster Fuller would later adopt the fat cigar–shaped concept for his Dymaxion Car of 1933, which bears a painful resemblance to a modern soccer mom's minivan.

medium, an auto. The car, of course, would have served to advertise Delaunay's business, axcept that her design did not sport a trade sign or logo. Doing something so avant-garde to one's car in the 1920s served as a sign of the allure and daring associated with forward-thinking modernity and, by extension, fashion. The painted car made a public statement.

Modern art didn't stay put in stuffy galleries; it was on the streets, in the cafés, worn on the body—it was lived. Young progressives distinguished themselves from the stalwarts of the stale past by listening to hot jazz, dancing the tango, wearing avant-garde fashion, driving the newest, fastest vehicles. The painted car of Sonia Terk Delaunay represents something unique on the boulevard, a manifestation of artistic license applied to the factory finish and to the process of living one's life. By painting her car in her signature style, Delaunay also indicated to the world her identity as an artist, a tradition continued to this day in the practice of artists making art cars.

The 1924 Parisian auto show was splashed across the cover of the French fashion magazine *Art-Goût-Beauté* as a "mechanical beauty show," suggesting that these new women drivers used automobiles as sex appeal with the "seductive power of a modern Eve." Tag Gronberg wrote in *Designs on Modernity* that "Delaunay's decorated car—along with the simultaneous clothing—is clearly an adornment of the female driver. The commodity (like a woman's body) appears as object of a desiring gaze and it is this display of desirable 'objects' which makes up the spectacle of the city." The car had arrived as a fashion accessory.

Across the Atlantic, Detroit got style as well—only in a more corporate, American model. GM's design division was launched in 1925, the same year Sonia

Delaunay painted her art car. Cars were no longer mere functional transportation—although Henry Ford refused to change for many years—allowing GM to eventually become the largest car manufacturer. A 1929 Hupmobile ad summed up the fad as "the lifting force of fashion that now sweeps through every American home…changing our lives, our homes, our clothes, our cities…creating a thirst for new beauty and new charm."

With the success of fashion as a marketing tool, GM president Alfred Sloan proposed in 1927 to add fifty employees to the design division and art and color section of Fisher, its body-making division. Soon, outrageous two-tone color schemes came out of Detroit, such as Avalon yellow or bolero red with raven black, gaudy chrome separating the shades. The 1950s Dodge LaFemme in pink and charcoal gray even came with a matching pink umbrella and pink purse rack.

Designers were commissioned by car manufacturers to add the fashion touch to their cars. "Hollywood set by Chasen's, Star fashions by Maurice Rentner, Catalina Four-Door Hardtop by Pontiac," bragged a 1956 Pontiac ad. Soon designers such as Bill Blass, Halston, Pauline Trigère, and even Levi Strauss were designing special-edition autos.

The main focus of fashion marketing was women, as a 1940 Ford ad pointed out: "My husband knows all about engines and brakes but I'm the expert on *Style*!…We agreed on a Ford V-8." A 1950s DeSoto ad advised that the extra-wide doors were "wonderful for party dresses and tight skirts."

Since cars were now fashion accessories, manufacturers encouraged women in particular to match their car interiors to their jewelry and clothes. "Oh, Darling! It's so

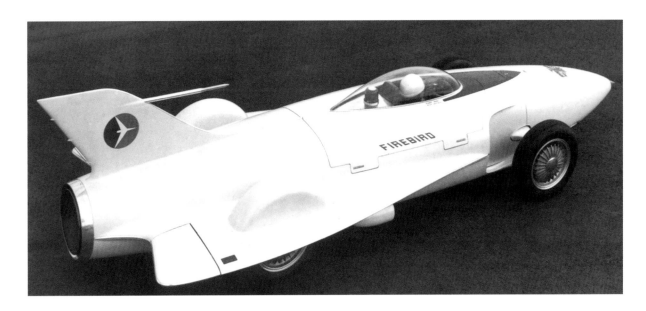

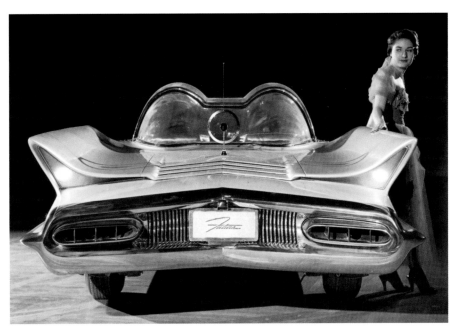

Lincoln Futura Prototype, 1955 (left) Who could resist the Plexiglas twin dome and circular radio antenna on the trunk? Hollywood couldn't. It snatched the Futura prototype to be Adam West's Batmobile for the TV series.

lovely that I haven't a thing to go with it," said a 1939 Ford ad. Cadillac ads featured expensive jewelry over their cars as the appropriate match to their luxury mobile. Even *Archie* comics portrayed Veronica Lodge as having a new car for each color of her fingernail polish.

In an effort to show women exactly what to wear in their automobile, a 1957 Pontiac ad promoted its "off-the-shoulder look" with a white-and-blue interior and "a dip on the seat to emulate the bare shoulder of the fashionable dresses of the time." A woman was pictured in a dress that matched the seats perfectly. The fashion would be updated the following year, making what GM's designer Harley Earl called "dynamic obsolescence." Alfred Sloan dubbed this planned obsolescence the "constant upgrading of product," with the goal of eventually encouraging consumers to purchase a new General Motors car annually.

By 1991 Citroën had finally learned the lesson that Sonia Delaunay taught decades earlier. Citroën's ZX was targeted toward four different middle-class subcultures, simply by changing the paint scheme and minor accessories on an identical car. The Reflex was aimed toward "tough, good-looking, and streetwise" women, and the ad featured a single mademoiselle with sumptuous long hair seductively and self-confidently getting into the car. The Volcane was for the young, urban man who was "fiery, dynamic, assertive, stylish." A red-blooded character, he is pictured laughing into his cell phone, leaning against the car. The Aura was "pure, unspoiled elegance" for the young, upwardly mobile couple pictured next to it. The Avantage was for a young mother with two kids, because it was both spacious and offered a "first-class cabin."

Today in the United States, 54 percent of all Volvo buyers are women. Volvo's prototype vehicle YCC (aka

**Firebird I Prototype,
1954** (top, opposite page)
Designed by Harley Earl's team, this GM prototype used an airplane's stick control to steer, brake, and accelerate. The driver/pilot clicked one of the first ultrasonic remote opening devices so he could pop inside the plastic bubble cockpit, which protected the passengers from G-forces. Drag brakes along the side of the car opened up like a crocodile's mouth to ease the car back into orbit.

Sonia Terk Delaunay's Citroën B12, 1925
Sonia and Robert Delaunay ascribed to their own type of cubism, dubbed orphism, which found its way not only into Sonia's fashion designs, such as the simultaneous dress, but also onto her car. Note the matching outfit for her fashion model posed outside Robert Mallet-Stevens's Pavillon du Tourisme in Paris. *Courtesy of a private collection*

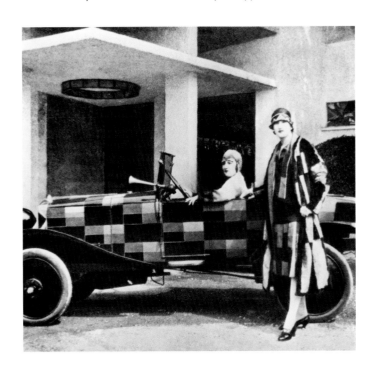

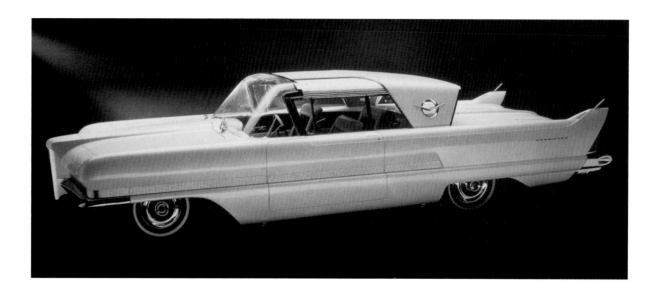

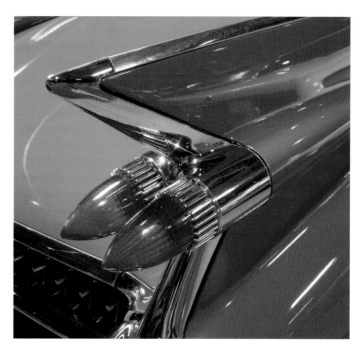

Studebaker-Packard Predictor, 1956 (above)
Built in just ninety days for the Chicago
Auto Show, the Predictor took airplane
styling to new Jetsonslike heights, with
tailfins and dual cockpits for driver and
passenger.

**Tailfins of a Cadillac Series
62 El Dorado, 1959** (left)
Fantastic 1959 rocket-ship styling make
these tail lamps look ready to blast out of
the galaxy. *Courtesy of the Louwman Collection*

DAF Clown Car, 1941 (opposite page)
De Rijdende Regenjas was built by DAF as
a circus car for clown Fried van Moorsel
of the circus 't Hoefke with a one-cylinder
Rolls Royce 125cc motor. Its super-skinny
body begs the question, How many clowns
will fit inside? *Courtesy of the DAF Museum*

Your Concept Car) was ostensibly designed by women for women and unveiled at the 2004 Geneva Auto Show. In this radical redesign with gender in mind, a ton of extra storage was thoughtfully included "for all our shopping bags." Special umbrella, cell phone, and key compartments were added, including a place for high heels next to the gas pedal so the driver could doff her unsafe spikes. The car has no gas cap, easy-clean paint, and an electronic parking-assistance mechanism. It even calls the service center itself when it needs maintenance. Then there's the hood, which cannot be opened by the vehicle's owner. "If a man designed a car like this, they'd call him a male chauvinist," declared Csaba Csere, editor-in-chief of *Car and Driver*.

The YCC-pioneered Ergovision scans your body at the dealership and stores size and shape measurements electronically in the car's ignition key as though designed by hypervigilant Homeland Security guards. The car offers eight changeable seat-cover combos in leather, linen, wool bouclé, and even a shimmery yellow-green embroidered fabric, each with a matching carpet.

Maybe all that coordinating is just redundant. The Mary Kay cosmetics lady already wears all pink, carries all-pink tote bags, and gets rewarded with a pink Caddy for selling the women of America lots of pink makeup. Mary Kay Ash bought a Cadillac in 1968 and had it repainted to match her Mountain Laurel blush cosmetic product. She then began the practice of rewarding top sellers with a pink Cadillac. The distinctive cars work as advertising for the company and as incentive for sales representatives. The shades of pink are exclusive Mary Kay palette selections and must be painted over if sold. The 1998 color was pearlized pink. In 2007, in a radical departure from tradition, the color changed to either black or smoky platinum. Accessorize your car for your lifestyle and buy often.

"Design these days means taking a bigger step every year. Our job is to hasten obsolescence. In 1934, the average car ownership span was five years; now it is two years. When it is one year, we will have a perfect score."

—Harley Earl, GM designer

THE BIG, BIG SHOW

Decorated cars shout out to be noticed, but when do art cars become purely commercial ads for big business? Early cart-and-horse businesses helped their trade by stenciling the name of the owner in bold letters across the wooden planks. Artistically bent promoters painted an image of the product to aid the imaginatively impaired and to include anyone illiterate, or the owners sometimes added sculptures to the wagon to attract more trade. Snake-oil sales were promoted with colorful wagons, singers, and even through novelty acts.

The wide, flat surface of delivery vans and semitrucks are billboards in motion along the highway and ideal for attention-getting graphics for commuters stuck on the road. Avery Dennison got back in the vehicle-decoration business when it joined other producers of printable large-format polyester film designed specifically to cover buses, trucks, and cars with computer graphics. Fuji, 3M, Asian, MACtac, Kapco, GMI, Hexis, and HP all got into making what amounts to giant stickers for fleet vehicles, an enormous market that continues to grow. Hand-painting, stenciling, or airbrushing graphics was suddenly obsolete due to this revolutionary alternative.

Sign Maxx, the New Orleans "Home of the Vehicle Tattoo," applies large graphics to clients' cars. The recent urban trend is to cover noncommercial cars with product logos for big name brands of candy, snack foods, breakfast cereals, and clothing product lines. Akin to sporting a Nike T-shirt or Baby Phat jeans, drivers report affinity for the products, while some have called the companies asking for post facto endorsement fees.

When capitalism descended on the former Soviet-bloc countries, ads rushed in to fill the vacuum of commercial spaces. The pink Barbie tram in Budapest stood out amidst the gray Socialist high-rises—a rosy apparition advertising a doll reminiscent of the famous expat bleached-blond bombshells the Gabor sisters. Most streetcars in Prague were already red and white, so slapping the Marlboro Man on the side was a logical visual transition. The blitzkrieg of glitzy ads shocked the former Communist countries, which had rarely seen the blatant capitalist promotions in the Old World cities. No neon existed on Wenceslas Square until the 1990s.

On the other side of Europe, advertising has long, decadent roots. The cyclists on the Tour de France are preceded by the *caravane publicitaire*, commercial vehicles that have been modified and sculpted to push their products. In advance of the yellow jersey, these modified cars zoom through towns and toss free samples to the thousands of fans. The advertising caravan reaches 15 million spectators—plus a television audience—with these eye-catching mobiles.

In the United States, the advertising vehicle stretches back at least a century. In 1933 the founder of the Radio Flyer company built a forty-five-foot-tall red Coaster Boy wagon for the Century-of-Progress World's Fair in Chicago. To commemorate that event and their eightieth anniversary, in 1997 the company built The World's Largest Wagon, which stands twenty-seven feet high and seats seventy-five kids.

Losing your lighter is such a common experience for smokers that disposable models went into production in 1973. The case of the missing Zippo car, however, still baffles company archivists and classic-lighter buffs. In 1947 a Chrysler Saratoga was customized for a whopping $25,000, with two oversized cigarette lighters blazing neon flames on its roof. The novelty car appeared in parades, and photographers captured its image in snapshots from the era. Left for repairs at a dealership that went defunct, the Zippo car hasn't been seen since the 1960s.

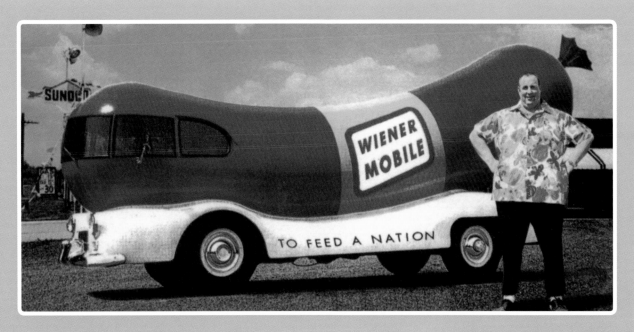

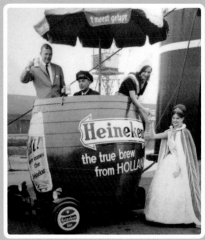

Wienermobile, 1936 (above)
Driving inside an immense hot dog was the brainchild of Karl G. Mayer, genius nephew of Oscar Mayer. In 1936 the company hired General Body Company of Chicago to make the vision a reality. *Used by permission of Kraft Foods/Oscar Mayer*

Roll Out the Barrel, 1962 (right)
The Heineken Beer Company's *Variomaton*, aka the *HeineKar*, was the '60s pop art creation of DAF, the Dutch automaker. *Courtesy of the DAF Museum*

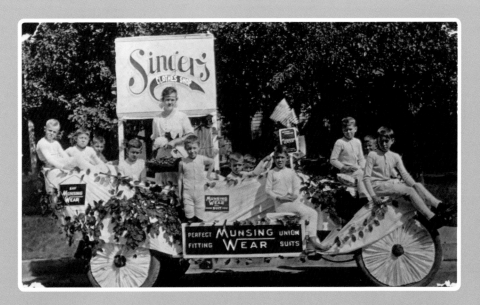

"Don't Say Underwear, Say Munsingwear!," 1908
George D. Munsing's "itchless" union suits were reason for celebration as youngsters no longer needed to have embarrassing scratching scenes in public. The Minneapolis-based company was so proud of the feat that it created a parade float with youngsters in skivvies for an Oklahoma parade of 1908. *Courtesy of the Minnesota Historical Society*

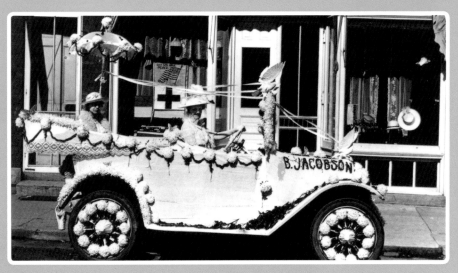

Belle Jacobson, 1916
Belle Jacobson owned the hat shop in the background of this photo. She decorated her car with flowers, ribbons, and a parasol to promote her woman-run shop for the 1916 Fourth of July parade in this Norwegian-American town on the prairie. Jacobson is driving, while Miss Kolie rides in back. *Courtesy of the Minnesota Historical Society*

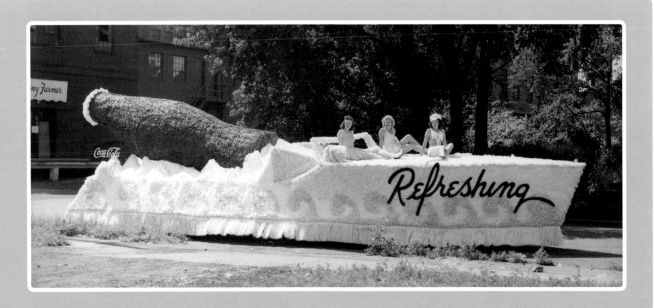

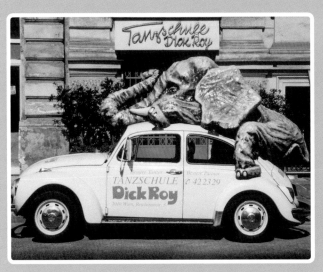

**Coca-Cola Company Float,
Aquatennial Parade, 1940**
After the violent trucker's strike of 1934 in
Minneapolis in which the police battled
unionists with batons, downtown died. The
Aquatennial Parade was started to revamp
the city's image, but in 1940 not even these
refreshing bathing beauties showing off a little
leg could lure the crowds back to the tarnished
city center. *Courtesy of the Minnesota Historical Society*

Love Bug Loved by Elephant, 1990
With promises to make you a "Better Dancer, Better
Partner," the Dick Roy Dance School of Vienna,
Austria, paraded its pink VW through the streets in
1990 to drum up customers ready to cha-cha-cha.

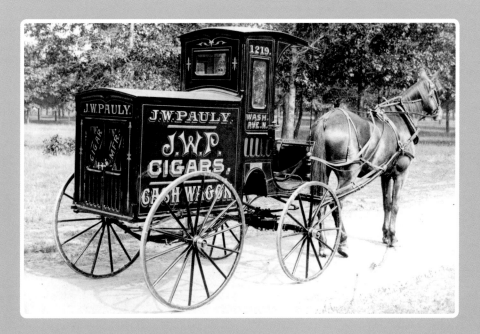

Cigar Wagon, circa 1890
Elaborate ornamental lettering embellishes the delivery wagon for the J. W. Pauly Cigar Company, Minneapolis, circa 1890. Early horse and cart businesses helped their trade by stenciling the name of the owner in bold text. *Courtesy of the Minnesota Historical Society*

Today, Prototype Source, a Santa Monica–based company, builds product-themed vehicles for companies, such as Hershey's *Kissmobile Cruisers* and the updated Oscar Mayer *Wienermobile*. These fiberglass-sculpted wonders appear like a movable Calder sculpture: oversized, out of context, slightly surreal, and meant to draw a crowd wherever they go.

The *Wienermobile* grew out of 1920s roadside vernacular architecture, such as the Brown Derby Restaurant, shaped like a giant bowler hat, doughnut stands shaped like big doughnuts, and Googie architecture novelties of the 1950s. The idea of hoisting an oversized frank in a bun atop a hot-dog hut had already been successfully accomplished by industrious

weiner vendors across the country, but driving inside of an immense hot dog was the brainchild of genius Karl G. Mayer, nephew of Oscar Mayer. In 1936 the company hired General Body Company of Chicago to make the vision a reality. To promote pork, the Oscar Mayer *Wienermobile* went on a tour from its home in Wisconsin to supermarkets around the Midwest. As the demand for hot dogs grew, the *Wienermobile*'s range grew to include the entire country by 1970. To celebrate its fiftieth birthday, the *Wienermobile* toured again in 1986.

A new generation of *Wienermobiles* has been created in twenty-first-century streamline moderne style atop a supercharged Chevy car body and outfitted with

GPS and high-tech PA system gadgets. These wiener spaceships are driven by Hotdoggers, who must have a college degree, a driver's license, and take an oath to promote meaty products wherever they go. Vanity plates on *Wienermobiles* run the gamut from OH I WISH to BIG DOG.

Similarly, Hershey's *Kissmobile Cruisers* are driven by Chocolate Ambassadors, who put on more than 30,000 miles a year driving to parades, stores, and children's hospitals, giving away oodles of chocolate kisses—to the joy of dentists everywhere.

Some of the most visually compelling commercial vehicles are the Red Bull cars, driven by Mobile Energy Team members—a fleet of attractive young promoters who drive new VW Beetles, Mini Coopers, and other trendy cars. A giant can of Red Bull is angled over the chassis to suggest to other drivers that they really need a drink. When a Red Bull car shows up at a party, free samples are passed out to get the young hipsters hooked on the caffeinated thirst quencher.

Another group to co-opt modern/retro cars is the Geek Squad, a computer-help service that took a squad of VW Beetles, painted them like saddle shoes, and plastered an unmistakable orange logo on the door.

Instead of using a car to promote a product, Quiksilver Inc. used its product to promote a car. Its street credibility with surf, skate, and snowboard fans was used by board designers, who painted several custom cars to promote the new Mazda 5 in 2007.

Rather than use a modern mobile, SpawMaxwell, a construction company located in Houston, grafted bulldozer Caterpillar tracks, a backhoe, and a front-end loader onto a mustard yellow Edsel. The parts snap on and off for transport to parades to advertise in the Lone Star State.

Another head turner—and possible traffic hazard—was the Powerball truck that advertised the get-rich lottery. Street Factory Media was hired by the Minnesota State Lottery to create a campaign in which actual cars "crushed" by giant red Powerballs were placed in surprising locations. A drivable milk truck crushed by a ten-foot red Powerball cruised about the state in a mobile tour of the theme. The project illustrated that lottery prizes are always big; "Don't Belittle Powerball," it warned.

Rather than modern trompe l'oeil like the Powerball, GSD&M advertising sought to re-create an early art car vision for the Houston Art Car Parade. Blue Genie Art took a tiny mass-produced consumer item, one of Ed "Big Daddy" Roth's devilish *Rat Fink* hotrod model kits, and made a large-scale reproduction, ironically built in the service of promoting a parade of one-of-a-kind, kooky, individualistic artworks. These demonic dragsters were icons of custom-car culture of the 1950s and 1960s, so creating a bigger-than-life-size monster art car of one of Roth's impossible visions was a dream come true for hotrod fanatics who one day owning the real thing.

Commerce draws on the artistic to make promotions spectacular. Some artists find commercial work an outlet for their creativity, but often the demands of the market can be limiting. Ad firms don't give artists free reign or carte blanche to pursue their muse, because they have a public image to uphold. For some artists, the freedom to make whatever pops into their skulls is only available in their free time, obtained by the support of commercial work. Art cars are a way to put original work with fewer limits into the forest of signs and advertising promotions occupying public space today.

The Origin and Appropriation of Buses

Disgruntled Swedish immigrant Carl Eric Wickman was sick and tired of mining in northern Minnesota, so he scraped together some cash to buy a Hupmobile dealership with one car for sale. None of the other miners could afford a pricey horseless carriage. "Everybody wants a ride, but nobody wants to buy a car," he lamented on May 14, 1914. For fifteen cents per test-drive, miners could take a spin, which inevitably stopped at their job at Hibbing's Hull-Rust Mine.

Since no automobile manufacturer made a larger vehicle for transport, Wickman and his buddy Andrew Anderson welded together a longer frame for the Hupmobile and added with more seats for the miners. These regular two-mile trips between Hibbing and the town of Alice began our national bus industry, all because Wickman couldn't sell his one car.

When the passengers piled on board the country's first bus, it wouldn't budge. The suspension couldn't hold the weight of the occupants, so the fenders were resting on the rubber wheels. The miners walked to work that day as Wickman and Anderson hastily attached leaf springs for shocks and zoomed to the mines to pick up the miners after work.

When the snow came, the transportation entrepreneurs had little choice but to hook up snowplows to the front of the makeshift vehicles and even arm one of their buses with a tank tread for traction on the icy road. These early vehicles had no comfy heating system, so dusty miners had to cuddle up under scratchy wool blankets.

Wickman's transportation service provided feeder bus lines throughout the Midwest to the expanding Great Northern Railroad. When a bus employee saw the long, sleek reflection of a dog on the metal side of an early bus, the company changed its name to Greyhound and moved to Chicago. The greyhound symbol became the third most recognized canine in America at the time—after Lassie and Rin Tin Tin.

American designer Raymond Loewy, the artist behind the iconic Lucky Strike cigarette logo and sleek chrome Electrolux vacuum cleaners, applied his streamline aesthetics to the Greyhound bus, first with the Silverside Motor Coach of 1940 and later with the Scenic Vista Cruiser of 1954. Greyhound bus travel in America was, for a while, efficient, modern, and elegant, a luxurious way to see the country. "Leave the Driving to Us!" the ads touted. The earliest buses are at the Greyhound Bus Origin Center in Bob Dylan's hometown of Hibbing, Minnesota.

Lobbyists from the auto industry bribed representatives of several American municipalities of the 1930s into dumping their mass-transit systems of streetcars and trolleys for new city bus routes. Buses in turn came into fierce competition with suburbanites' individual automobiles. Intercity bus and train service diminished over the years in the United States as private ownership of cars increased. Bus service in developing countries, however, flourished as building the infrastructure for railroads was often too expensive in remote locations. From Pakistan to Guatemala, bus drivers decorate their buses with religious shrines to protect the passengers from accidents along bumpy mountain roads.

Today, buses in many developing countries are gaily painted wonders, serving as a source of individual expression and pride for the driver. The distinctive decoration can also serve to identify the correct bus to board for a particular route to a sometimes-illiterate populace.

Buses are particularly useful for transporting equipment and people, like politicians, traveling bands, and theater troupes, and when used this way, they are

decorated with emblematic themes. Paul Wellstone, the antiwar populist senator from Minnesota, selected an aging green bus for his whistle-stop grassroots campaign vehicle. In homage to Paul and Sheila Wellstone, killed in a plane crash in 2002, Pam Christian and Mina Leierwood made *Vehicle for Change* (aka the *Wellstone ArtCar*), a mobile green monument covered with vignettes, portraits, peace stickers, slogans, and symbols of the late senator's ideals.

Some of the older buses in the United States and Europe were picked up by hippies as an instant mobile home to escape the drudgery of suburbia, or as The Who sang, "Watch the police and the tax man miss me, I'm mobile!" Painting the magic bus was important to both distinguish the occupants as radically different from the rest of "straight" culture and to prevent mistaken identity by schoolchildren needing a ride. Young high school graduates in Norway (the Russ) buy old buses, paint them red, and spend a solid month partying on them before settling down into humdrum adult life.

Most memorably, Ken Kesey and his Merry Pranksters drove their psychedelically painted bus misnamed *Furthur* across the United States to upstate New York in 1964 for a summit meeting with Timothy Leary, the king of mind-altering drugs. When Kesey arrived, Leary couldn't be roused from his slumber after a three-day LSD binge. Even if Leary had been coherent, a discussion between the psychedelic kings would have been heated. Kesey's tactics of dosing unsuspecting victims with a hit of LSD didn't jibe with Leary's scientific ideas that hallucinogenic drugs should be kept in a controlled, laboratory-like setting.

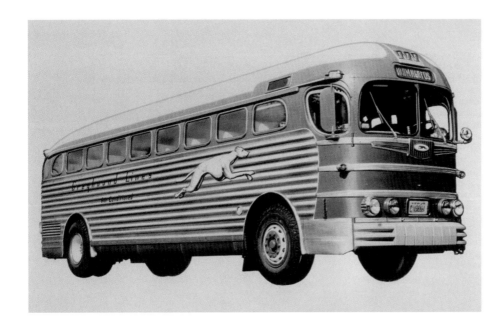

Silverside Motor Coach, 1940
Applying streamlined modern aesthetics to mass motor transport, American designer Raymond Loewy created the Silverside Motor Coach for Greyhound. One can't ignore the similarity between Loewy's space-age Electrolux chrome vacuum cleaner and this space-age chrome Cruiser.

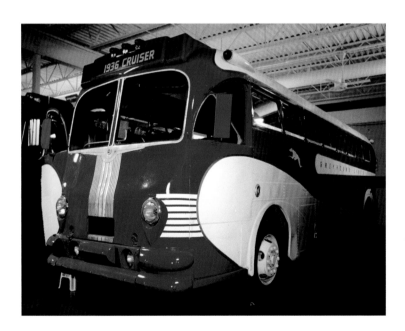

GREYHOUND SCENICRUISER

Introducing a great New Era in highway travel!

Greyhound Scenicruiser Ad, 1954
Designer Raymond Loewy's bus sported second-tier windows like the Vista Dome observation cars in trains of the day. By seating passengers up top, luggage could be stowed in innovative, easy-entry, curb-level compartments below. Greyhound bus travel in America was, for a while, efficient, modern, and elegant.

Greyhound Cruiser, 1936
Now relegated to a dusty warehouse at the Greyhound Bus Museum on the Iron Range of northern Minnesota, this Cruiser had a slick two-tone blue paint job and art-deco-inspired streamlining.

Tom Wolfe wrote about Kesey, Wavy Gravy, and the rest of the Pranksters who drove their colorful bus into Palo Alto to set up an "acid test" in 1965, when LSD was still legal. The Grateful Dead supplied the music, and guitarist Jerry Garcia declared that it was the best audience he ever had. "I thought you ought to be living your art, rather than stepping back and describing it," Kesey said. The bus is "a metaphor that's instantly comprehensible. Every kid understands it."

Kesey and Leary were soon put in jail on drug charges, but the rest of the Merry Pranksters kept the artistic bus traveling around the country. Soon the Hells Angels were turned on by the Pranksters, as shown in Hunter S. Thompson's book about the outlaw motorcycle gang. Once the Angels were "on the bus," their motorcycles suddenly took an artistic turn, with more chrome and customization than ever before.

The psychedelic influence on moving vehicles continued in Janis Joplin's trippy Porsche and John Lennon's paisley Rolls-Royce. Timothy Leary paid a visit to St. Louis's hippie hangout the Venice Café, painted with a sweeping kaleidoscope of colors by Jeff Lockheed. The artist took Leary out for a spin around town, and Lockheed was so inspired that he painted a classic 1948 Crosley à la the Merry Pranksters' bus in homage to Leary.

"People think of a bus as transportation," Zane Kesey, Ken's son, said. "No. It's a platform, a way to get your messages across."

The Smithsonian tried to acquire the Merry Pranksters' bus, but in true form Kesey pranked them by giving them a copy. The original Merry Prankster bus is parked at Kesey's farm in Oregon, and there are plans by his family to restore it.

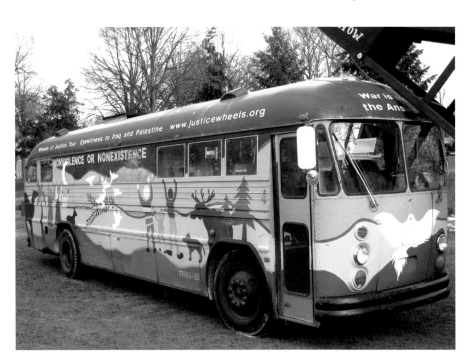

Wheels of Justice, 2008
The *Wheels of Justice* biodiesel tour bus is staffed by an all-volunteer group seeking universal human rights and equality under the law. Their mission includes education, outreach, and nonviolent actions, as well as raising support for home rebuilding, refugee aid, and advocacy work worldwide.

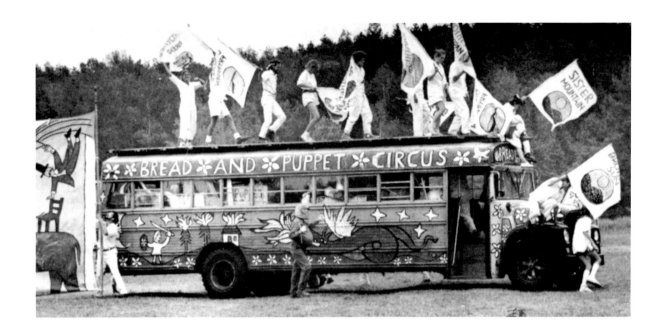

Bread and Puppet Theater Tour Bus, 1987
The Cheap Art movement was launched in 1982 by the Bread and Puppet Theater from Glover, Vermont, in direct response to the corporate sector's growing appropriation of artistic designs. According to the theater company, with commercialization all art becomes "political, whether you like it or not..." The hand-painted bus still provides the wheels for the activist puppet troupe to tour the United States. *Courtesy of Bread and Puppet Theater*

History of Hippie Vans, 2001
"Eleven long-haired friends of Jesus in a chartreuse Microbus," sang C. W. McCall in his classic trucker song "Convoy." *Luna, The Goddess Landscape* is one of many art cars by Texan and "commuter activist" Shelley Buschur.

The Birth of the Love Bug

The Volkswagen Beetle became the most popular car in the world during its 1960s heyday. American cars in the 1950s had grown bigger and more expensive, so the Bug was a starter car for millions of youth on a limited budget. How many frat boys can you fit in a Beetle? Bored kids in the backseat bruised each other's arms every time a "slug bug" came into view. Herbie the Love Bug appeared in multiple movies as the little engine that could.

The burgeoning counterculture inspired creative and pychedelic paint jobs, and some hippies could afford the VW Microbus for an even larger canvas on which to paint their LSD-infused muse. The automobile that came to symbolize the "turn on, tune in, drop out" generation did not have such a rosy past, though. The company whose car would eventually outnumber the legendary Model T in sales not only used Ford as a role model for its ideas in mobilizing the masses and marketing its car through word of mouth, but also drew from Ford's concept of keeping its employees in line.

The idea of the Beetle began during Adolf Hitler's stay in prison; he devoured Henry Ford's autobiography, *My Life and Work,* and then penned his own memoirs, *Mein Kampf.* While Hitler praised Ford's five-dollars-a-day mentality as long as workers behaved properly, Hitler's Italian contemporary Antonio Gramsci—who was also jailed—thought otherwise. In his essay "Americanism and Fordism," Gramsci warned that Ford's ideas—including a private security force of 9,000 to watch over and spy on workers to prevent unions, talking, or even whistling—were dangerous precedents in controlling employees.

Although Hitler never learned to drive, he loved being chauffeured around. He made German traffic regulations more lax and getting licenses and registering cars easier. He even announced in a promotional frenzy at the 1934 Berlin Motor Show that "the car...would be particularly beneficial to the less well off, which would not only prove useful to their way of life, but would also enhance their Sundays and holidays, giving them a great deal of future happiness." Only a populist for some of the populace, he was also envisioning the Final Solution.

By 1936 Ford-AG was the fifth largest car manufacturer in Germany and second in truck production. As much as Hitler admired Ford, he wanted a German car for the masses, what he dubbed a *volkswagen,* or "folks' car." Rather than going into full-scale production at home, Hitler would control Ford factories in eight countries by 1940. He envisioned a car for less than 1,000 reichsmarks, whereas the more practical Ferdinand Porsche, who designed it, thought the VW would cost 1,500 reichsmarks (about $600). It was to be produced by a government department for workers' recreation, called KdF or *Kraft durch Freude,* which meant "Strength through Joy" in classic doublespeak style.

Erwin Komenda, Porsche's top engineer, was the designer behind the style and look of the original Beetle, drawing on art deco–era interest in aerodynamic looks and Bauhaus-influenced simplicity of materials and functional form. The Beetle design also owed much to the Czech Tatra T97, and VW had to pay Tatra 3 million deutsche marks in damages in a 1961 settlement for stealing the T97's original design from the 1930s.

The prewar VW advertising campaign raged and encouraged workers to invest ahead of time to purchase a KdF Volkswagen, exactly as Henry Ford saw his own employees as a market for the Models T and A. In Germany, however, most never received their car. Instead, Deutschland was gearing up cars for the war effort, with men from the SS secretly testing prototype VW38 cars on back roads. The early VW was designed

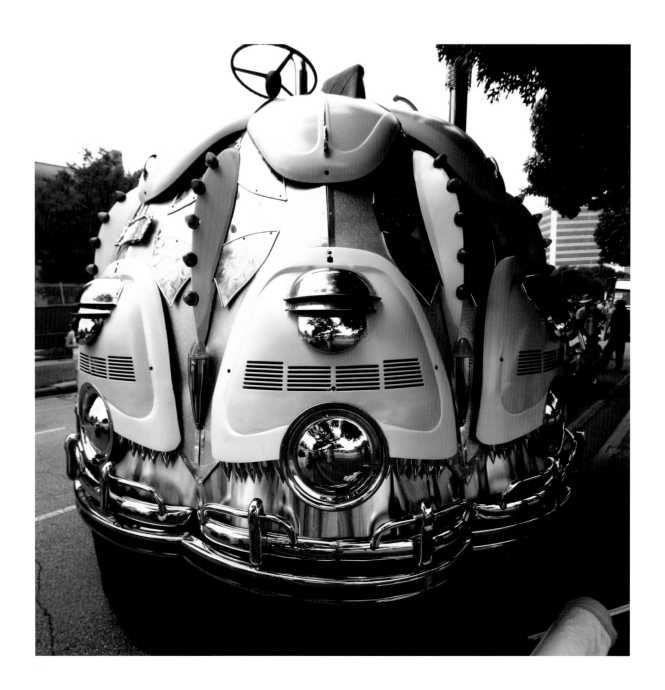

Lady of Transportation
(opposite page)
Car by Amber Eagle and
Todd Parsons. *Courtesy
of Jason McElweenie*

**Bulldog Bug,
Belgium, 2008**
Like a Chihuahua that
thinks it's a Great Dane,
this Bug has aspirations
to be a streetrod.
Equipped with dirt-track
tires, steel running
boards, and an orange
racing stripe, the dents
say it's seen some real
action. *Courtesy of Luyckx
Van Gestel Beetle Wheels*

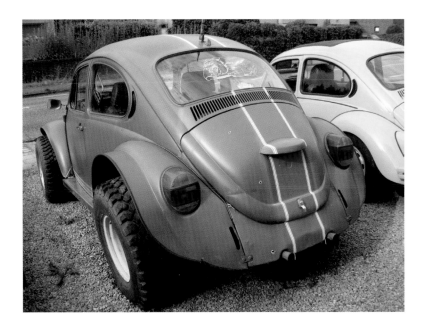

**The Inspiration
for the VW?**
Following a 1961
court case, Volkswagen
had to shell out
3 million Deutsch
marks in damages
to Tatra for stealing
the Czech company's
original design from
the 1930s. The Hans
Ledwinka design for
this spectacular 1936
Tatra T87 sedan was
manufactured by
Ringhoffer-Tatra Werke
AG in Czechoslovakia.
*Courtesy of the Minneapolis
Institute of Arts*

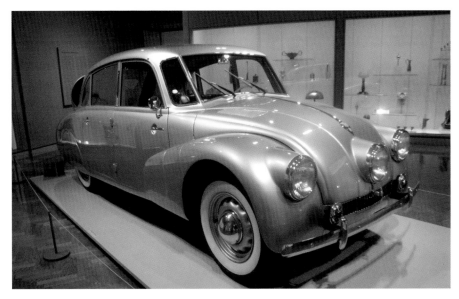

without the typical wooden floors, which would be combustible in an attack, and with curved windshields instead of angled or flat windows, which would reflect light to planes overhead. Perhaps not privy to these war specifications, Ferdinand Porsche questioned whether the KdF plant was building war machines rather than cars—ironic considering that VW was inspired by the Model T, and Henry Ford would later drag his feet about joining in the war effort against Germany.

The plans to mass market the Volkswagen were canceled following the invasion of Poland. German citizens who had paid into the KdF plan were required to keep financing a car that they would never see. At the end of the war, Russian troops confiscated the remainder of the savings.

At the end of the war, the abandoned VW plant, already damaged by bombs, was further wrecked by the workers, probably POWs forced to work for the Axis. The factory would have been totally leveled by looters if it hadn't been for a French priest who begged the encroaching Americans to occupy the town. The priest asked them to protect the investment of the German-American workers that Porsche had brought to the factory before the war because of their experience in American car factories.

As part of war reparations, Ford was offered the Volkswagen factory, upon which Ford president Ernest Breech said to Henry Ford II, "Mr. Ford, I don't think what we are being offered here is worth a damn!" The VW Beetle went on to beat the Ford Model T as the best-selling car of all time.

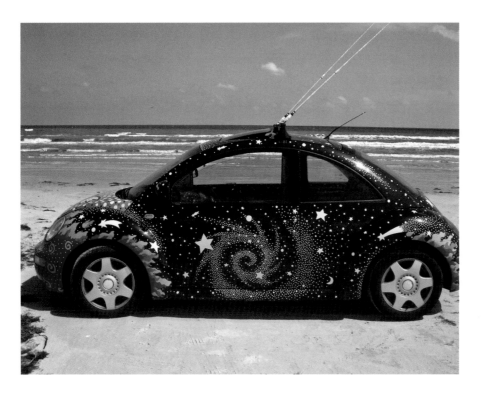

Twink (left)
Twinkle, twinkle, little *Twink* braves the surf of the beach in Galveston, Texas. As the author of children's books, as well as being a photographer and designer, Max Haynes took his brand-new Beetle and transformed it into a cosmic super Bug to inspire youngsters. *Courtesy of Max Haynes*

Rocky Roadster, 1997 (opposite page left)
A rolling stone gathers no rust. Doug Flynn encrusted his Bug with stones and filled the rear windowsill with his cactus collection, which flourishes in the southwestern sun of Albuquerque, New Mexico. *Courtesy of Brian Longley*

"I shall do my best to put his [Henry Ford's] theories into practice in Germany…I have come to the conclusion that the motorcar, instead of being a class dividing element, can be the instrument for uniting the different classes, just as it has done in America, thanks to Mr. Ford's genius."

—Adolf Hitler, 1933

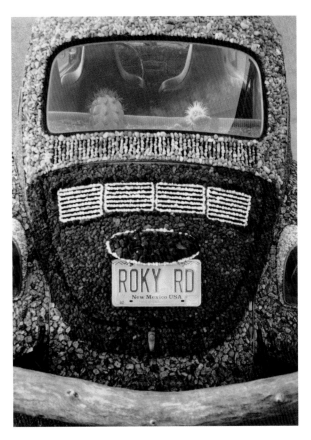

Pasta Bug (top right)
David Pampili created a maccheroni masterpiece for the Pasta Festival in Foligno, Italy. *Courtesy of Maury Landsman*

California Dreamin' (bottom right)
This classic Love Bug longs for the hippy heyday along I-90 in southern Minnesota.

Alien Vespas, 1956
Dressing up their Vespas as aerodynamic spaceships, *lunaires* (moon men) zipped around a Parisian square in 1956. *Courtesy of Hans Kruger Archives*

Eureka! A Good Yarn (inset, opposite page)
Tim Klein's *Yarn Car* ferries Miss Mary Matthews in a couture chapeau made by fellow art car artist Natali LeDuc in the 2008 Eureka Springs, Arkansas, Art Car Parade. *Courtesy of Tim Klein*

ART CAR PARADES

"What do you get when you have three art cars in a row?"

"A parade!"

For some auto artists, the spectacle is the whole point. In a culture that idolizes being seen, art cars get more than their share of double takes and finger pointing. But if parades are fun to watch and be in, then why not hold them every day, all the time? Parades give the participants license to hold up traffic, interrupt normal routines, and shamelessly call attention to themselves.

Parades stem back to the earliest communities. Military might could be shown in a lavish display of chariots, armaments, and troops on horseback. Religious ceremonies can include promenades through the streets. One of the earliest written references to a parade comes from 1800 BC when King Senwosret III of Egypt stated, "I celebrated the procession of the god Up-wawet." In 500 BC Greece, a statue of the god Dionysius was carried from his temple in a festival car pulled by two men before a theater production commenced. Rulers since antiquity have shown off their wealth and power in grand coach processions accompanied by marching bands and honor guards. The pope goes out in a phalanx of vehicles led by the Popemobile, which lets him be seen by crowds through bulletproof Plexi. Religious holy days, college sporting events,

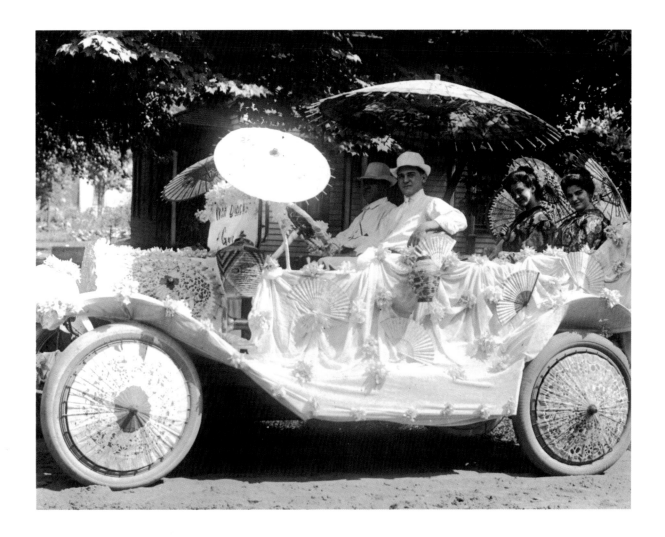

Japanese-Themed Car, 1910
Before Pearl Harbor, Frank Lloyd Wright and other midwesterners were
obsessed with Japanese design and its exotic elegance, as seen in
this parade float. The white geishas acted coy as the dapper driver
struck a colonial pose on this horseless carriage covered with oriental
fans, paper parasols, and lanterns as it made its way down a main
street on the prairie in 1910. *Courtesy of the Minnesota Historical Society*

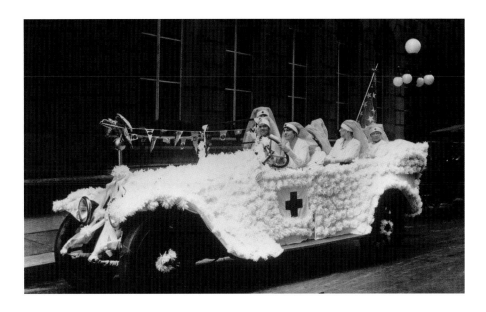

Red Cross Parade, 1917
WWI nurses in nunlike uniforms aboard their angelic, floating-cloud car as it glides down the streets during a 1917 Red Cross Parade. *Courtesy of the Minnesota Historical Society*

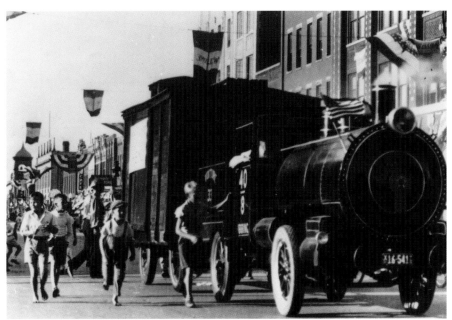

Car as Train, 1935
Kids flocked to hear the whistle blow as this train car huffed for an American Legion Convention Parade. Little did anyone suspect that the automobile would trump the train in connecting the coasts. *Courtesy of the Minnesota Historical Society*

secular holidays, and commercial marketing activities are marked by festival processions with statues and tableaus carried by the faithful, decorated carts, and rolling floats. At the Tournament of Roses Parade in Pasadena, floats are built by professionals and run a production tab of up to $200,000 each.

Art cars, by nature, cry out to be seen. A comparison can be made between these movable art pieces and festival floats, except that art car owners can often brag that they run their altered automobiles year-round. "Daily driver" is in fact one category in contemporary art car parades. These car artists prefer to take their art with them everywhere, rather than just to special events. According to philosopher Michel de Certeau, "Everyday practice patiently and tenaciously restores a space for play, an interval of freedom, a resistance to what is imposed (from a model, a system or an order). To be able to do something is to establish distance, to defend the autonomy of what comes from one's own personality." Daily drivers of art cars move about town with the knowledge that they are on the one hand being disruptive and on the other insisting upon simply doing ordinary errands such as commuting to work or stopping at the bank.

The current boom of car art is highlighted at annual rallies, parades, and roundups. Artists gather to admire each other's handiwork and show off to the public as a group. Many community festivals have spiced up events with art car parades, recognizing the fun, interactive aspect of this public art form. While art car festivals are most common in North America, England's first art car parade was held in Manchester in 2007.

Art car parade organizers have promotional reasons for claiming to be the first or the oldest such event; however, decorated cars have been caravanning through the streets since autos were first invented. The Art Car Museum of Houston unearthed records of decorated cars from that city in 1902. A search in the Minnesota Historical Society archives turned up a Parade of Decorated Vehicles from 1905. The Art Car Weekend

sponsored by the Orange Show in Houston is currently the biggest such event, with hundreds of participants annually from across the country and the world. Other large annual gatherings include the ArtCar Fest in San Francisco and the ArtCar Parade in Minneapolis.

As annual events evolve and grow, new challenges present themselves to the organizers. Social theorist Max Weber suggested that new rules tend to represent past conflicts. For example, the rule concerning no open flames in the Houston parade guidelines recalls an unforeseen incident of a vehicle-mounted flame-thrower setting some boulevard trees on fire along the procession route.

Some parade participants use these public forums for their free-speech potential. *Phone Car*, built on a 1975 Volkswagen Beetle chassis, is the creation of Boston business owner Howard Davis. Licensed and street legal,

Number Six in Parade of Decorated Cars, 1905 (top left, opposite page)
Riders aboard horseless carriage number six were hoping for first prize after spending hours covering their car with excelsior bunting.
Courtesy of the Minnesota Historical Society

Elks Club Car, 1915 (bottom left, opposite page)
To show off its civic pride, the Elks Club decked out their Winton automobile with a racked elk to butt through the streets.
Courtesy of the Minnesota Historical Society

***Cork Truck* Detail** (top right, opposite page)
Courtesy of Aaron Landry

Jan Elftmann in Wheels as Art Parade, *Cork Truck* (bottom right, opposite page) *Courtesy of Max Sparber*

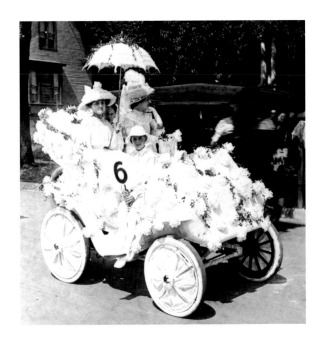

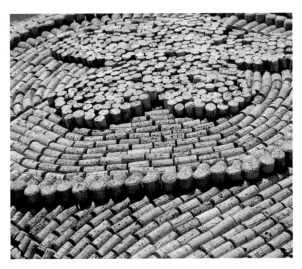

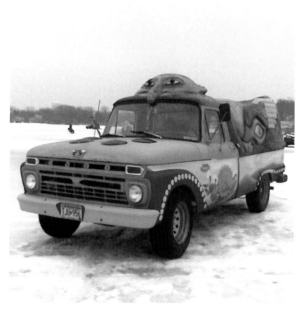

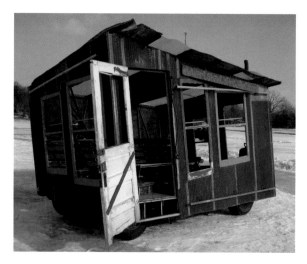

Elmer on Ice (above)
Sculptor Allen Christian carved *Elmer* out of insulation foam to keep his truck toasty for Art Cars on Ice. *Courtesy of Erika Nelson, World's Largest Things*

Mobile Home (left)
Mobile Home is a pedal-powered shanty on truck wheels created by Julia Kouneski. Seated pedalers propel the shack across the frozen ice. *Courtesy of Art Shanty Projects*

Anishinabe Legacy (top left)
driven by Maryanne Harstad, painted by Damon, inspired by artist Ray Thomas. *Courtesy of Erika Nelson, World's Largest Things*

Arms Race (top, opposite page)
Tom Kennedy made pointed political commentary with his *Missile Truck,* accompanied by the Missile Dick Chicks, with their message that peace is patriotic. Kennedy reveled in spectacles, promoting his lifelong idealism.

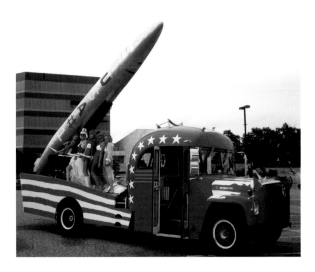

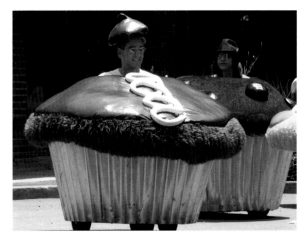

Muffiners
Jon Sarriugarte, seen here, welded his own chocolate cupcake car, part of a set built by "muffiners" over electrics carts chargeable by solar panels. Originally built for Burning Man 2004, they have multiplied. *Courtesy of Rick Washburn*

Phone Car was driven cross-country by Hunter Mann in a 2008 US tour, with stops at numerous parades and events along the way. Mann rolled the giant red phone up to Senate offices in 2008 to deliver a message: Stop FISA (the Foreign Intelligence Surveillance Act). The late Tom Kennedy's creation, *Missile Truck*, stirred controversy and was banned from some parades. Consisting of a full-size Cold War–era rocket and gantry atop a circuslike red, white, and blue vintage International Harvester, with an entourage of Missile Dick Chicks in risqué attire, the vehicle was meant to raise alarm over military escalation and saber rattling in election years.

ArtCar Fest in San Francisco has dynamos Harrod Blank, Philo Northrup, and Emily Duffy as festival organizers, all with their own spectacular art cars. The author of two books and several documentary films on art cars, Blank has done much to increase public knowledge of and appreciation for this medium. His *Camera Van* is densely covered with secondhand picture-taking devices, many of which take snapshots of gawking spectators. Who is viewing whom? From the dashboard the artist can work switches that capture the likenesses of unaware gaping viewers. These spontaneous unposed photos perfectly portray the sheer delight and awe a stunning work of mobile art evokes.

Partly due to the need to distinguish their venue, Minnesotans devised the first, and as far as they know only, art car parade across a frozen lake, Art Cars on Ice. Lakes in the Far North freeze solid enough in winter to support automobiles and pickups. Handy ice-thickness pocket guides are distributed to ice-fishing enthusiasts so they don't fall through. Each February—barring global warming—the Minnesota Artist Vehicles trek across frozen Medicine Lake with their wheeled creations to the surprise of the occupants of ice-fishing huts. Recently, The Soap Factory, a Minneapolis arts organization, has sponsored the Ice Shanty Project in which artists creatively design themed shacks based loosely on the ice-fishing shelter. Art cars serve as taxis for the project, shuttling visitors

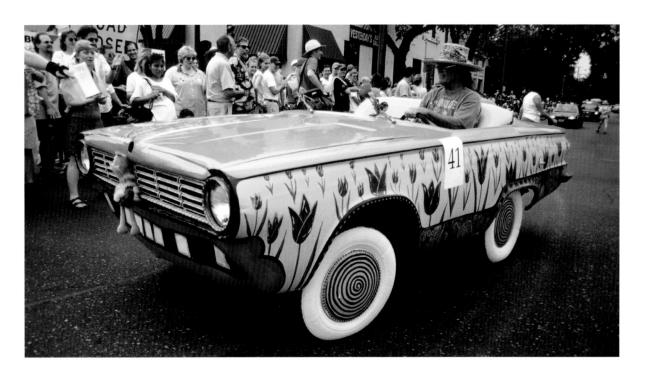

Dean Pauley Driving _Miss Vicky_ (above)
A mobile tribute to Tiny Tim's first wife, Miss Vicky, Dean Pauley's tulip car carried the high-voiced singer in its debut tour during Mardi Gras, complete with waving tulip windshield wipers (on an imaginary windshield). Tiny Tim lived out his golden years in the midwestern suburbs and had a fatal heart attack while playing "Tiptoe through the Tulips" to a packed audience at the Woman's Club. While some lowrider custom cars are "sectioned" by taking out a horizontal layer all around the bodywork to make the auto appear lower, _Miss Vicky_ was sectioned vertically to turn the four-seater Dodge Dart into a tiny love mobile for two.

Mobile Magic (left)
Sandy Elftmann drove the _Faerie-Elf Car_ during St. Paul's 2007 Grand Old Day Parade as fairy princess Madalina Kelner held up a "Honk if you believe in fairies" sign.

The *Amazing Sole Car*
Conrad Bladey, self-proclaimed peasant and Irish studies professor, created many art cars, including the *Art Gurney* and *Handy Car*. Here is his *Amazing Sole Car,* "saving soles daily." *Courtesy of Tim McNally*

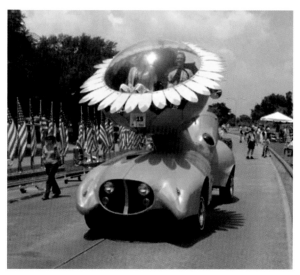

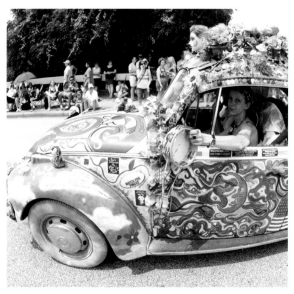

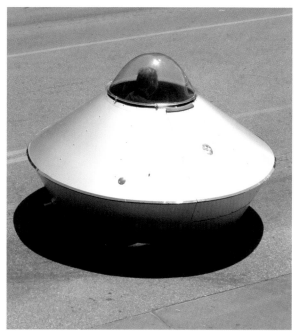

(Clockwise from top left)
Dave Major's *Propeller Car*
Airplane stylings inspired Dave Major of Benton, Kansas, to graft stubby wings and a propeller onto the body of a BMW Isetta. Ready for takeoff, the aerocar whirls down a parade route.

Sunflower Power
This giant green sunflower by Timothy Young cruises in the Houston Art Car Parade.

It Came from Outer Space!
The *Flying Saucer from Outer Space* by Pat Slimmer invades Kansas for the 2008 Art Tougeau Parade. *Courtesy of Ann Dean*

Fusion of Contradiction
With "Art Gal" vanity plates, this VW by Brandi Renee Hammond juxtaposes the star-spangled banner with the classic hippy Love Bug for a new meaning. *Courtesy of Alex Luster*

Shell Game (below)
The lowrider *Turtle* ambles down the street in a 2005 Art Car Parade, pausing to delight children by extending its neck out of the shell. *Courtesy of Bryan Kennedy*

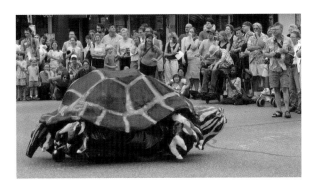

between the shore and the shanties, providing some protection from the below-zero windchill.

St. Paul, Minnesota, boasts the nation's oldest and largest winter festival, the Winter Carnival, dating back to 1886. Parades of wintry floats and, later, decorated cars with well-bundled snow queens still sleigh past enormous ice castles built just to defy the cold and melt away come spring. Vulcans in devil outfits, the bringers of warmth, ride fire trucks and wreak havoc throughout the festival. Contemporary art cars participate in the chilly St. Paul Winter Carnival in honor of the longstanding tradition.

Peter Lochren, creator of *Ambulance to the Future*, and partner Christine host the Central Art Car Exhibit & Celebration in Omaha, Nebraska, each year. Participants are treated to visits to local folk art attractions, such as a great doughnut shop featuring hundreds of poodle pictures and a stop at a local art museum. Many rallies incorporate visits to the local children's hospital, art center, or other nonprofits in need of art and entertainment.

The Banana Bike Brigade began in 1994 at the St. Louis Taproots School of the Arts. More than thirty members travel around the country in costume with themed bicycles. As "America's premier parading art bike group," their mission is "to make people more aware of the art around us and the happiness that art creates." Most of their profits go to charities, which plays into their community-building philosophy.

Playwright Antonin Artaud envisioned a new "poetry of festivals and crowds, with people pouring into the streets." Referring to theater as a lived gesture, he wanted "an intensive mobilization of objects, gestures, and signs, used in a new spirit." Making your own parade is a subversive act in a culture that tells you where to line up. Parades may be innately human and likely began as a show of military might, but art car artists march to the drumming cylinders of their own customized vehicles.

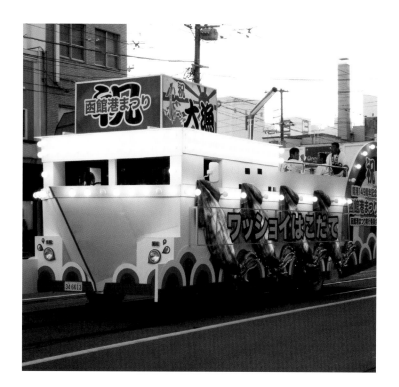

Squids in Transit (top left)
Hakodate, on the island of Hokkaido in Japan, hosts a *Minato Matsuri,* or harbor festival, for its famous squid harvest. Here an army truck has been modified to celebrate the wriggly catch. *Courtesy of Masaki Suzuki*

Singing Fish (bottom left)
The *Sashimi Tabernacle Choir* trolls for applause from the throngs at the 2008 Houston Art Car Parade. Houston hosts the largest such event in the world. *Courtesy of R. Steven Rainwater*

Fish Out of Water (below)
Karen Haselmann navigates her *Fish Bike* through the crowds at the 2008 24th Annual May Day Parade. The parade featured tall bikes, costumed bikes, rolling floats, and even a pedal-powered mobile tin shack.

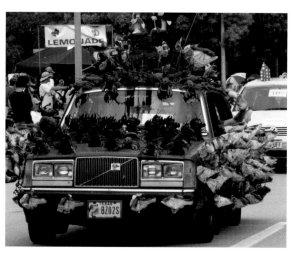

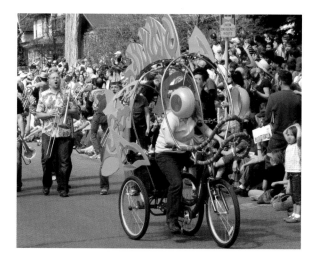

Camera Van

Inspired by a dream, Harrod Blank created the *Camera Van* to take candid photographs of an awestruck public. Of the 2,500-plus cameras, there are several video cameras and ten Canon EOS cameras that function and are operated by shutter buttons on the dashboard. On the passenger side, a "film strip" of four working thirteen-inch TV monitors displays the unique footage and photography. The *Camera Van* also appears in Harrod's feature documentary film about art cars, *Automorphosis*. When not on tour, the van is displayed at the Art Car World Museum in Douglas, Arizona. *Courtesy of Harrod Blank*

Coolest Celebration on Earth

Devilish Vulcans aboard their fire trucks represent nature's epic battle between spring warmth and winter's brutal cold. Symbolic pageantry at the annual Winter Carnival Parade dates back to 1886, while motorized Vulcan Krewes first appear in 1940. Here they escort Max Haynes's *Twink* and Ruthann Godollei's *Volvo with Green Gears* in 2004.

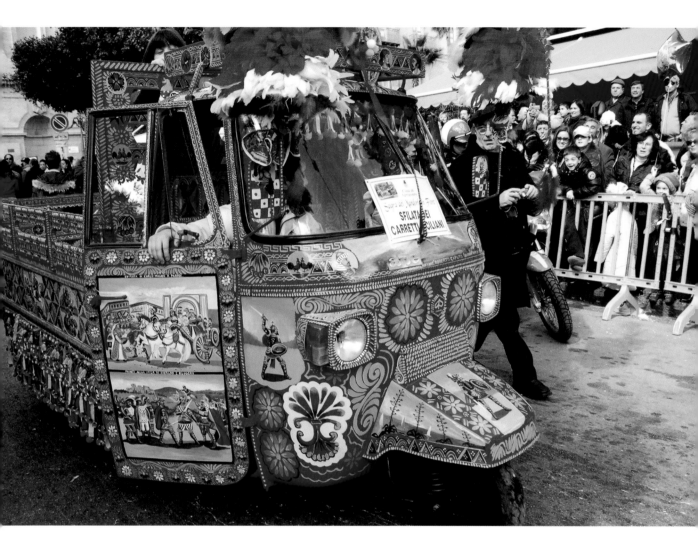

Old and New
Contemporary Sicilian Ape minicars are being decorated in the tradition of the painted wooden *carretti* and used in the same manner in parades and wedding processions. *Courtesy of Giuseppe Marena*

Painted Truck, Delhi, India (inset, opposite page)
The hand-painted floral motif of this truck is set off by a framed folk art painting of an idyllic landscape with houses on the passenger door. **"**No place like home" is a common theme for those who live on the road. *Couryesy of Lela Pierce*

CIRCUMNAVIGATION

Many art car enthusiasts assume that decorating their daily drivers is a uniquely American idea. While many outrageous designs have found happy homes on Main Street, USA, artists in developing countries have viewed public buses, trucks, and carts as the perfect canvas to transport their artistic prowess through the countryside. Rather than sequester their creativity to the cramped interior of a stuffy museum, artists have created movable galleries that bring their handiwork to the most remote village every time the bus arrives.

Art Vehicles around the World

Just as the Catholic Church commissioned sculptors and artists to design the interiors and exteriors of churches worldwide, many Mexican artists use decoration on vehicles to declare their reverence with movable shrines to the saints. The Virgin of Guadalupe dashboard display at the front of a bus makes for a de facto Mass of the faithful sitting dutifully in their bouncing seats.

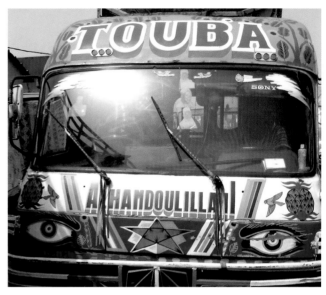

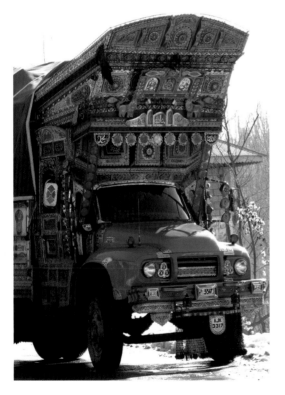

Ape Car on Ischia, Italy (top left)
As the three-wheeled version of the Vespa, Piaggio released the Ape, or Bee, in 1947 for small transport, or in this case as a decked-out maritime taxi/rickshaw for open-air sightseeing during picturesque sunsets on the island of Ischia. In a few minutes, the canvas top could pop up and provide shelter from the storms blowing in off the Tyrrhenian Sea.

Spectacular Mountain View (bottom left)
Pagli the Truck, or *Silly Girl,* climbs the snowy hills in Pakistan in her best winter outfit. *Couresy of Mujahid ur Rehman*

Le Car Rapíde, Sénégal (above)
In Sénégal, Le Car Rapíde is the cheapest public transport. These bright minibuses often bear the phrase *Alhamdulillahi* (thanks to God). Praying might be appropriate, as the driver only slows down for potential passengers while the ticket collector, precariously hanging from the rear door, calls out the vehicle's destination. *Courtesy of Bo Anderson*

Central American buses are often painted with the owner's name—or that of a sweetheart—in a sugary floral design. Guatemalan "chicken buses" carry passengers as well as small livestock in conveyances painted the bright colors of the tropics. Almost 3,000 of these colorful buses chug through the streets of Panama City, so in 1983 the Panamanian government picked the twenty-four best bus painters for a juried art show entitled Los Buses de Panama at the Museo de Arte Contemporaňeo. Styles splashed across the side of the buses ranged from simplistic two-dimensional cartoons to droopy-eyed moppets to slick seventies airbrushed babes, and themes ranged from sultry mermaids to the industrial cranes of the Panama Canal to Mr. T.

Just as Richard Zamboni used war-surplus Jeeps to make the first ice resurfacers, enterprising mechanics in the Philippines used the same old World War II military vehicles to piece together the first Jeepney. A cross between a jitney and a Jeep, the frame was usually extended to fit more working-class passengers, and originally homespun decorations covered up the drab olive green of wartime. An ingenious solution to postwar transportation shortages, the Jeepney is a symbol of canny Filipino make-do culture. Today these lorries can be bought new, then are decked out with chrome accessories and dolled-up extras such as multiple horns, lights, stickers, custom paint, hood ornaments, fetishes, and flags. These flashy trucks proclaim loyalty to politicians, affiliations with groups, faith in the Lord, undying love for a sweetheart or pop diva, flagrant commercialism, and boisterous veneration of the hottest sports stars. As a reaction to global influences and cultural imperialism stifling local talent, these Jeepney artists transform international pop culture into something uniquely Filipino.

Artist Godofredo Stuart maintains an informative website on Jeepneys and states, "In a country devoid of any populist program of art, where art is an indulgence of the literati and bourgeoisie, Jeepney art is probably the sole venue for expression of true proletarian art."

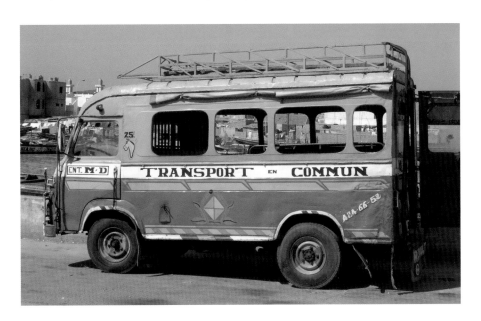

Transport en Comun, Saint-Louis, Sénégal
Le Car Rapíde is the public bus system for the common person in Sénégal. Brightly painted sturdy old Renault minibuses are the basis for the fleet. *Courtesy of Caroline Verschueren*

Historian Moira Harris wrote extensively about elaborately hand-painted vehicles in the developing world in *Art on the Road: Painted Vehicles of the Americas* and claims that the first decorated vehicle in Haiti was a Jeep painted for the Centre d'Art Gallery of Port-au-Prince decades ago. This spawned the construction of hundreds of Haitian tap-taps, meaning "hurry up" in Creole. These trucklike buses with extensive woodwork cost just a few hundred dollars to paint. The drivers often spend the most money on the elaborate woodwork for the passenger compartments and fancy stereo systems to entertain the customers (and cover up the noise of the clunky engine). In an otherwise poor country, tap-taps have become such a symbol of pride, faith, and creativity that they are the most popular Haitian landmark pictured on postcards.

Similarly, in Sénégal, Le Car Rapíde is the cheapest public transport, consisting of brightly painted and decorated minibuses operated by Muslim brotherhoods. They often bear the phrase *Alhamdulillahi* (thanks to God). Praying might be appropriate as the driver only slows down for potential passengers while the ticket collector precariously hangs from the rear door, calling out the vehicle's destination.

With new forms of transportation, old means are often dumped and the art that had been carefully painted on the side is forgotten. The Chivas of Colombia used to roam throughout the country in relatively large numbers, but now few of them have survived the ravages of putzing around crack-filled mountain roads. Once again, the Chivas use old American trucks,

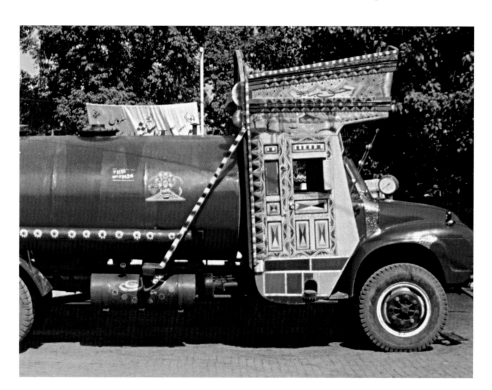

Tank Truck, Lahore, Pakistan
Utilitarian trucks in Pakistan and Afghanistan have a long tradition of elaborate decoration. The cowl above the cab can take on architectural forms, while the sides get painted with flowers, oasis themes, sayings, poems, and good luck charms. *Courtesy of Don Celender*

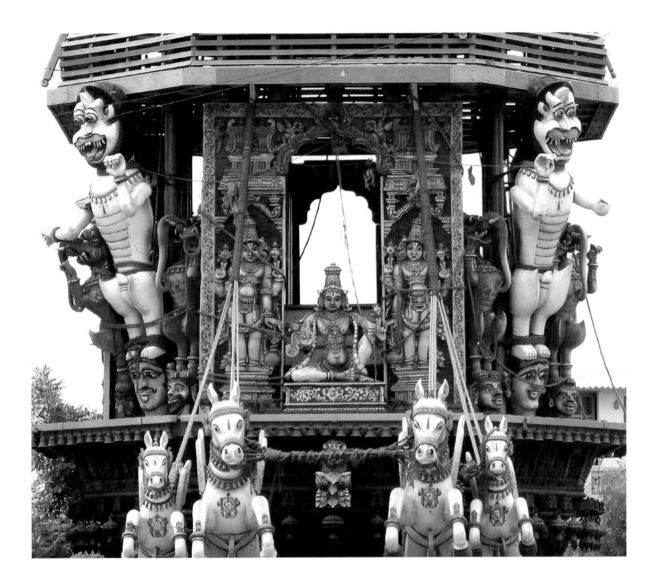

Sacred Cart
Temple carts are still made today in India and can be built several stories high, brightly decorated with religious carvings and sumptuous silk canopies. This moveable monument belongs to one of the temples located near Kanchipuram, Tamil Nadu, India. *Courtesy of Balaji Shankar*

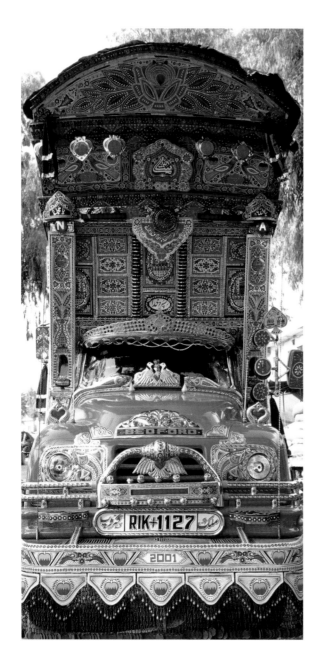

Sicilian Donkey Cart (above)
Carretti are lovingly decorated for parades and religious processions. The wooden carriage is often overlain with carved wood and beautiful metalwork painted with folkloric and historic scenes, while the donkey is festooned with plumes, embroidered harness, and ornate bridle. *Courtesy of Giuseppe Marena*

Jingle Truck (left)
So-called jingle trucks host skirts of chains in rows with metal ornaments hung below, creating a sonic and visual experience for the bystander. Stunning Pakistani and Afghan truck paintings illustrate themes from religion, myth, and modern life. Some have mosaics, mirrors, reflectors, or tokens that guard against bad fortune. These high-style trucks are beloved workhorses, hauling regular goods overland daily, as seen in this photo at the wholesale fruit terminal in Rawalpindi, Pakistan. *Courtesy of Jamal Elias*

usually flatbeds, as the base and then an entire wooden structure is built on top to make it look like a factory-finished bus—in a rainbow of colors. A couple of wooden ladders extend up the outside of the bus to the large wooden luggage rack on top, earning these vehicles the nickname *camiones de escalera* (ladder trucks). When the buses get too crowded, passengers scurry up the ladder to the roof rack for some fresh air and a bumpier ride. Many of the Chivas don't have a long aisle down the middle but have open sides along each of the benches so passengers can easily hop on and off. The vibrantly painted Chivas usually have a large landscape painted on the back—often the home or destination of the vehicle.

In Ghana, carpenters and artists of the Ga tribe continue to make beautiful fantasy coffins in forms associated with items used, loved, or merely wished for by the deceased, including fancy cars. Persons who could not afford a Mercedes or a Ferrari in life get to occupy a detailed wooden facsimile of one in eternity. Honoring the dead with these elaborate and

expensive coffins supports the concept that ancestors in Ghanaian culture still play a protective role in the family. "It is believed that if the deceased is properly honored, such actions secure spiritual favor for the family left on earth," according to the National Museum of Funeral History in Houston. Wooden cars, trucks, and taxis might have the owner's real license plates affixed to the bumper for their journey to the netherworld. Symbolically, a customized coffin adorning a car motif also endows status on its occupant in the afterlife, as the real item does in the here and now. Carpenters in Accra have begun a modest export trade in the car-shaped containers via the Internet.

Truck drivers on many continents share the road romance of the displaced, the exile, or the one who longs for home, and these themes show up in the paintings and decorative treatments their vehicles display. Trucks in Pakistan and Afghanistan have a long tradition of stunning decoration. So-called jingle trucks host skirts of chains in rows with metal ornaments hung below, creating a sonic and visual experience

Trabbant Prowls Berlin

Cheap cars in ex–Soviet bloc countries are something of a cultural in-joke. Trabbants, Skodas, and Ladas today prompt the former owners to feel *ostalgie*, a play on the words *nostalgie* (nostalgia) and *ost* (East). This jungle-theme-painted Trabbant advertises a German ecotourism travel company.

Photograph by Greg Bugel, courtesy of Colibri Travel

Heavy Hauler (above)
Parked in a bazaar, this Indian bicycle rickshaw has intricate hammered and punched brass panels. Brass vases attached to the front axle act as flower holders to charm tourists.

Women from the Ndebele Tribe of South Africa (top right)
Traditionally, Ndebele women decorate the outside of their homes in bold geometric patterns. These artists painted a car for a cultural demonstration in New Zealand. *Courtesy of Philo Northrup*

for the bystander. Pakistani and Afghan truck paintings illustrate themes from religion, myth, and modern life. Some have fantasies in poems or proverbs, others charms for good luck that guard against bad fortune. Along with painting, surfaces are sometimes covered with glass mosaic tiles, bits of metal, plastic, carved wooden relief elements, tassels, and reflectors. The cowl above the cab can take on architectural forms, impressively rising over the terrain in structures reminiscent of mobile shrines.

The highly stylized public transportation in developing countries dates back to the long tradition of decorating horse, ox, and donkey carts around the world. For example, *carretti* are traditional utilitarian Sicilian donkey carts made of wood and metal. Both cart and donkey can be lovingly decorated. The wooden carriage is often painted with folkloric and historic scenes, with carved wood and beautiful metalwork, while the donkey is festooned with plumes, embroidered harness, and ornate bridle. Artisan specialists in cabinetmaking, blacksmithing, and painting collaborate to make this means of transport fanciful and functional. Wedding buggies have even more ornamentation than work carts and carry stylings specific to their Sicilian province. These carts can still be spotted in Sicily today, although in fewer numbers. The *lapa*, a contemporary three-wheeled motor cart used for light-duty hauling in Sicily, is sometimes painted like a *carretto* of old to keep alive the tradition. The Museo del Carretto Siciliano in Palermo is a museum dedicated to the carts, and an annual parade of *carretti* puts the masterpieces of this form on public revue.

Slovak Performance Car Art
(bottom right, opposit page)
In 1998 artist Norbert Kelecsényi of the Fine Art Academy of Bratislava covered his car in colorful plastic toy prize pods and dropped it by crane before setting it aflame. *Courtesy of Jenny Schmid*

Nicaraguan coffee growers introduced the idea of oxcarts to their neighbors in Costa Rica, who used *las carretas de bueyes* to haul coffee beans and sugarcane. The sides of the carts were painted to represent proud moments in Costa Rican history as a sort of education mobile for youngsters. The coffee growers bristled at outsiders' recommendations to grease the squeaky wheels, because "farmers' wives were accustomed to listen for the distinctive sound of their husbands' carts, and thus for them it became the welcome sound of return," according to Moira Harris. Many of these carts are now proud museum pieces, and perhaps the big buses—whether tap-taps, Jeepneys, or Chivas—will take their rightful place in the artistic canon of each country.

Early Soviets enthusiastically put on parades and demonstrations in honor of their new czar-free country. Bolshevik festival vehicles included over-the-top rolling paeans to munitions factories, production output, worker solidarity, planned monuments, and heroes of the revolution. Optimism faded as the deprivations of wars, bureaucracy, purges, and shortages produced by the arms race became the reality of Eastern-bloc life. Modern car designs in the Soviet Union became even less artful than those in the United States and Europe. Pressure from the Duma to increase production likely caused Soviet manufacturers to produce even more carlike vehicles that were less than roadworthy.

Cheap cars in ex–Soviet bloc countries are something of a cultural in-joke. Trabbants, Skodas, and Ladas today prompt the former owners to feel *ostalgie*, a play on the words *nostalgie* (nostalgia) and *ost* (East). As art cars, these old Eastern-bloc cars are infused with extra symbolism due to the repressive past. Slovak artist Norbert Kelecsényi used his old car in a performance piece at the Fine Art Academy in Bratislava in 1998. First covering the vehicle in round red and yellow plastic toy prizes, he then bribed workmen to hoist it up in the air by crane and drop it, after which it was ceremoniously set afire.

To avoid using gas-guzzling land yachts as a canvas, many artists take the idea of art cars and apply it to environmentally friendly bicycles. Penny-farthing bikes and unicycles may have been standard fare for three-ring circuses, but modern artists instead bedeck their cycles with creative extensions to make animals, rockets, and whatever else their imagination inspires. In the 1990s a movement to revive these tall bikes was launched by industrious bike mechanics across the country. Discarded bikes and parted-out cycles were remade as two or more bike frames mounted on top of each other. Extra-long chains and tandem brake cables made the tall bike move and stop. In Japan, *dekochari* (decorated bicycles) are the ride of choice for *dekotora* monster truck fans who are too young to drive.

After monster trucks made a hit in Japan in the 1970s, cyclists who couldn't afford these giant mobiles opted to pimp their bicycles, known as *dekochari*. The bikes were enlarged with plywood boxes that were often carpeted, enladened with reflectors, and chromed to make them look like mini–monster trucks.

The first contemporary tall-bike club was probably the Hard Times Bike Club (aka the Black Label Bike Club). This bike movement spread to international anarchist DIY bike groups with names like the Subversive Choppers Urban Legion, Rat Patrol, and Cyclecide.

Dino Cars are heavy-duty German-made pedal go-karts, pedal cars, and bikes. The Evers family started the company more than 100 years ago as an agricultural equipment service, but today manufacture an enormous amount of upscale toy vehicles at their plant in Rhede, Germany. The toys aren't just for kiddies anymore, as Dino has found a new, adult market for bikes and trikes with add-on covers, shells, and canopies.

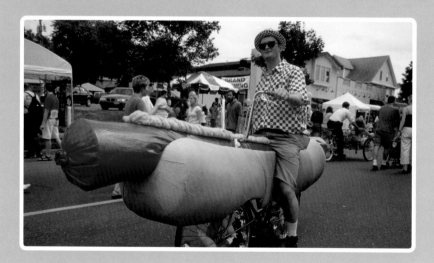

Hot Dog!
Chris Koehler rides astride the big dog. Banana Bike Brigade members make costumes for their bikes and attend parades across the United States. Most of their profits go to charities, part of their Play for Peace, community-building philosophy.

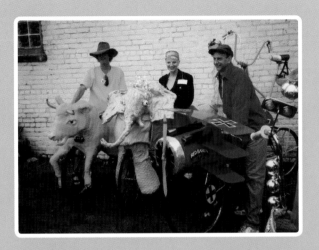

Banana Bike Brigade (top left)
This St. Louis troupe travels to numerous parades to show off their two-wheeled creations. *Fernando the Bull* and *Tallulah the Pink Elephant* accompany Uriel Starbuck, founder of the Banana Bike Brigade, atop his indomitable *Red Baron*.

Eternal Spring (above)
There are tens of thousands of bikes in Amsterdam, but unique adornments make it easy to spot this sweet ride along the canals.

Tricycle to the Moon (left)
David Best's *Cosmos Trike* is a three-wheeled version of his hooped *Carsmos* car. It looks destined to go into orbit around the Art Car Museum, where it is docked. *Courtesy of the Art Car Museum*

Jinrikisha is the Japanese word for "human-powered vehicle." Rickshas were originally nineteenth-century peasant-pulled two-wheeled transport for elites in Asia. The practice has seen a worldwide revival via the pedal cab, also known as the pedi-cab in the UK, bicycle rickshaw in India, *cyclo* in Vietnam, *becak* in Indonesia, *saika* in Myanmar, *samlor* in Thailand, or *taxi ecologico* in Mexico. Often used for urban tourist transport, they can be elaborately decorated to attract trade or identify a sponsoring company.

Bikes can also have costumes rather than permanent alterations, and some theater troupes find they make good rolling substructures for puppets in motion. Bare Bones Theater in Minneapolis hosts Dumpster Wars, a junk-based make-off that tests the ingenuity

Head and Shoulders above the Crowd (left)
A tall bike cruises through Powderhorn Park, in Minneapolis.

Tall Bike, Long Bike
(right, opposite page)
The first contemporary tall-bike club was probably the Hard Times Bike Club of Minneapolis, and here's an assortment on display at the Blind Lizard Rally on Nicollet Island in 1995. Discarded bikes and parted-out cycles are remade as two or more bike frames are mounted on top of each other.

Pedal Pub
(left, opposite page)
Beer aficionados in the Twin Cities can be seen drinking and driving on this twelve-person cycle.

of the participants on a short deadline. Troupe member Douglas Saldaña made a unique narwhal bike sporting its single horn, swimming through air as he rides it.

A safe solution to drunk driving, which includes the ability to continue to drink while riding around, is proposed via *partyfiets* (party bikes), found throughout the Netherlands. The mobile-bar bicycle can seat a dozen beer lovers and a steerer, all pedaling off the calories while on the carouse.

Dekochari (left)
Eccentric bicycle customized by an elderly Japanese gentleman with an ominous Orwellian warning on the sticker: "Someone is watching you." *Courtesy of empirik*

Surf's Up
(left, opposite page) Eric Farnsworth's Bicycle Laboratory has made offbeat bikes from his "bucking bronco exercise machine" to a cycling lawnmower. Here stands a true hybrid vehicle, a *Surf Bike. Courtesy of Ann Dean*

Goofybike
(right, opposite page) There's room for his whole family and mom working a sewing machine in this cozy domestic unit on wheels by Charles Steinlauf of Chicago.

"Mass culture tends toward homogenization, the law of wide-scale production and distribution, even if it hides this fundamental tendency under certain superficial variations destined to establish the fiction of 'new products.'"

—Michel de Certeau

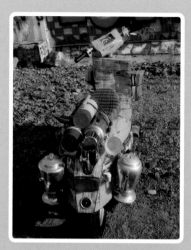

Fueled by Folgers
What makes it go? Admirers flock to check out the caffeine-themed décor of Smitty Regula's *Percolating Coffee Psycho* scooter from Houston, Texas.

Art car artists like to be seen, so why hide behind that windshield? One remedy is to decorate an old Vespa or Lambretta scooter for a visual spectacle that highlights the driver as well as the vehicle. The problem remains, though, of how to alter these pithy two-wheelers for maximum exposure.

Because motor scooters have always been relatively inexpensive, owners haven't been too concerned with covering the putt-putts with stickers, spraying on their own paint schemes, or giving their rides some personality so they stick out from the thousands of two-strokes. Irreverent teenagers have sawed off the end of their tailpipes for a smidgeon of added power, and even in 1957 the Shriners convinced Nebraska-based Cushman to offer a Masonic scooter with leather fringe and shiny rivets to show off the steeds, as well as adding chrome widgets including horns, safety bars, floorboards, air shrouds, seat rails, locking gas caps, and fender tips.

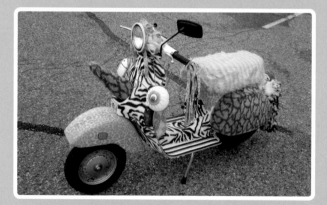

Soft Machine
James Buhler covered his scooter in a fantasy array of soft fabrics. His helmet has a fuzzy pastel mohawk to match his ride.

With all these dolled-up scooters, parades soon followed. The very first Vespa Club was established by Adolf Nass in 1951 in Saarbrucken, Germany. After turning heads of incredulous pedestrians, the scooterists didn't know what else to do other than set up dangerous obstacle courses, called gymkhana, to test their riding agility and laugh at the worst accidents. To further raise eyebrows, industrious scooterists welded together bizarre hybrid vehicles that were part scooter, part automobile, and part airplane. Many spare parts from bombed-out Italian airplane factories found their way onto these little mobiles. Three- and four-wheeled scooters bridged the gap between the automobile and the scooter, and personalized decorations followed.

In the tradition of José Guadalupe Posada, Mexican printmaker Artemio Rodríguez makes satiric relief prints commenting on events of his day, politics, love, life, and death. Both artists employ *calaveras*, humorous skeleton figures found in Day of the Dead celebrations in Mexico.

Born in Tacámbaro in the Mexican state of Michoacán, Rodríguez and artist Silvia Capistran first founded La Mano Press in Los Angeles and then in Michoacán. La Mano makes original prints and books the old-fashioned way: printing by hand from linoleum blocks and silk screens.

Expanding prints on paper onto three-dimensional objects such as skateboards and vehicles, Rodríguez created his 2006 masterpiece *El Muertorider* (Dead Rider), a 1968 Chevy Impala customized in collaboration with artists John Jota Leaños and Sean Levon Nash of Burning Wagon Collective. He also made *GraficoMovil: Mobile Center for the Graphic Arts*, a 1947 Chevy delivery truck adorned with his bold graphic designs. Rodríguez envisions his role as "an instigator of sensibilities, imagination, and further creativity. Artists are inspired by life," he says, "and life is nothing without the certainty of death to give it limits and meaning."

El Muertorider
Mexican printmaker Artemio Rodríguez customized a 1968 Chevy Impala with artists John Jota Leaños and Sean Levon Nash of Burning Wagon Collective. As the cofounder of La Mano Press in Michoacán and Los Angeles, Rodríguez sees his role as "an instigator of sensibilities, imagination, and further creativity." *Courtesy of Artemio Rodríguez*

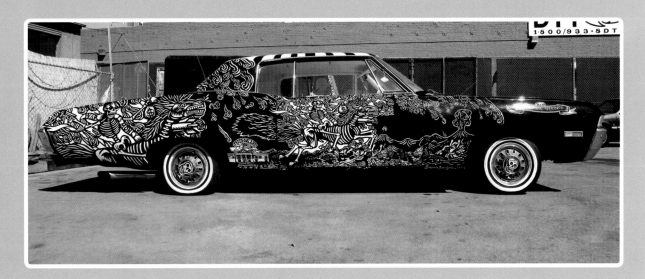

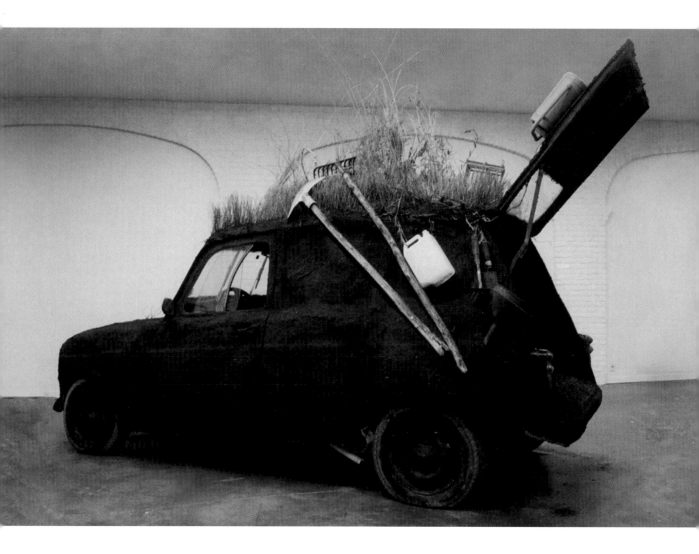

Earthcar
Peter Decupere, "aromatic artist," organizes "smell happenings" in his native Belgium. Inside the earth-covered car are books made of dirt with the text "Smell the Earth."
Courtesy City of Brugge project and Peter Decupere

Truck Rod (inset, opposite page)
Classic styling, perfect in every detail. This truck waxes nostalgic for the days of Midget Car races (named for powerful, small race cars) at Gilmore Stadium in LA, which sponsored Gilmore Red Lion gas stations' promotional racing giveaways.

OFF THE PRODUCTION LINE

Cars are mechanically reproduced en masse. People buy vehicles ostensibly reflecting personal tastes, but also reinforcing ideas about themselves in terms of class, status, wealth, education, sexiness, and so on. Someone buys a Lexus to declare his or her access to wealth and status, or, more commonly, as social theorist Judith Williamson describes, a poorer person has dreams *about* buying one in envy of a more well-off future self. Owners of hybrid cars might be speaking about their education and concern for the environment, while at the same time needing a certain level of wealth and excess capital to say this. There is no mass-produced car that tells the world, "I am an artist." So some artists have taken it upon themselves to declare their calling to the world by making their vehicle a work of art.

In his early writing, French philosopher Jean Baudrillard discussed the prestige ascribed to identification with acquiring a new sports car or the power transferred to the person when driving one. He noted that cars, like most consumer commodities, have sign value and are bought and displayed as much or more for these intangible properties as for their use value or usefulness in modern society. But what if the car's owner altered the vehicle and snubbed the idea of displaying wealth?

The idea of consumption as a way to gain status in a social system was developed by Thorsten Veblen. He coined the phrase *conspicuous consumption*, describing defining

oneself in relation to a society built on buying things. Your identity is created when others respond to what you have. Most people have an expected reaction to a Rolls-Royce or a beat-up AMC Pacer, but what about a car covered in real green grass?

Baudrillard postulated "an active manipulation of signs," made possible by participation in consumer society through selection, modes of display, and the attempt to distinguish oneself from others. While later theories of consumption deemed this impossible—consumer cultures on hyperdrive co-opt all forms of difference and dissent—art car artists may come closest to the idea that there is a way to insert oneself into consumer society with some attempt at human agency. Artists do try to produce their own signs, make their own symbols, and employ tactics of resistance to complacency and sameness. Art car artists do this in the medium of the ultimate mass-produced consumer object: the automobile. Art car artists put the *conspicuous* in *conspicuous consumption* in a distorted over-the-top, self-conscious display.

> "Not only does an art car question the standards of the automobile industry, but it expresses the ideas, values, and dreams of an individual."
>
> —Harrod Blank

Customizing the Factory Finish

When Henry Ford's Models T and A were sent to the scrap heap, teenagers in Southern California got interested. In the exodus of Okies to California during the Dust Bowl of the 1930s, poor farmers sold off their jalopies for little or nothing. *The Grapes of Wrath* turned into *American Graffiti*, Oklahoma meets California, as the old cars were souped up to impress the girls.

Hotrods were born, and homespun mechanics outdid each other every year with new techniques. Metallic flames seem to burst out of the engines in candy-apple red paint schemes. The front hood was scrapped to show off the V-8 engine dropped in to replace the clunky old one. Who needs bumpers when youth is invincible? The goal was to make cars look like they were breaking a land-speed record while standing still. *American Heritage* magazine termed hotrods the "supreme folk art of the American century."

The squares of straight society were shocked—shocked! A Goodyear Tire & Rubber Company promotional brochure titled "Welcome to the Highway, A Special Greeting to the Youth of America" came with safety advice for midcentury teens. Aimed at discouraging hotrod hooligans, one page tsk-tsked a leather-jacket-wearing, cigarette-smoking, old-car-driving James Dean wannabe as "attempting to substitute attention for his lack of earned recognition." This stern pop-psychology warning contrasted with a clean-cut pair of tall, blond high school grads in cap and gown with their trophies on the facing page.

Ed "Big Daddy" Roth—along with Neil Emery, Gene Winfield, and George Barris—defined a look for the outlaw hotrods, playing with custom bodywork and the recently invented fiberglass molded into outrageous forms. Roth designed custom theme cars such

Beatnik Bandit Hotrod by Ed "Big Daddy" Roth, 1960
The 1960 *Beatnik Bandit* was mutated from a 1955 Oldsmobile engine and body. Roth began playing with custom bodywork and the recently invented fiberglass, molding it into outrageous forms. This creation was immortalized as both a Revell model car kit and one of the first Hot Wheels toys. *Rat Fink*, Roth's most famous creation, appears in the background. *Courtesy of Moldy Marvin*

Mysterion by Ed "Big Daddy" Roth, 1963
The 1963 *Mysterion* enclosed the driver in a Cyclops-inspired bubble top and combined two souped-up Ford engines that couldn't be contained within the confines of the tiny hood. *Courtesy of New Langdon Arts*

as *Beatnik Bandit*, *Mysterion*, and *Road Agent*, but he became most famous for a drawing of a hotrod monster named *Rat Fink*. Roth-inspired products such as T-shirts and model car kits sold in the millions in the 1960s. His iconic style continues to be popular today with *Tales of the Rat Fink*, a movie about Roth's life.

When Big Daddy Roth went to the big drag race in the sky, his casket was lovingly pin-striped by his dragster compadres. Pin-striping had taken the street rod world by storm as auto aficionados polished the chrome and used Q-tips to clean every inch of the tangerine flake, baby. As historian Moira Harris wrote, "Custom painting began in California, but today it is a national art form." Inspired by the cartoon character Kustom Kemp, Jerry Titus founded Kustom Kemps of America to promote dolled-up street rods and lead sleds at fairgrounds around the country. While classic fifties cars often had miles of chrome, lead sleds were stripped of the shiny metal and the remaining holes filled with Bondo.

Ratrods bucked the hotrod trend of gussying up the car. A bare-bones speedster with no frills, it was often stripped of bodywork to make it appear unsafe at any speed. Salt flats, dried-up lakes, or old runways became dangerous racetracks. *American Graffiti* became *Faster Pussycat! Kill! Kill!* in 1965 with three lusty, busty babes in speedsters out to ruin a Goody Two-shoes who lost her way.

Not to be left out, Detroit auto manufacturers of the turn of this century created readymade hotrods such as the Plymouth Prowler and the Chrysler PT Cruiser. No need to learn to weld or get oil stains on your jeans, these cars evoked the nostalgic feel of the custom rod through design features such as a lowered front, metallic and candyflake paint, wide tires, and skinny windows. They came with the latest safety features and interior conveniences. The limited edition PT Cruiser came with "front, bright accent ring cup holders" and "illuminated vanity mirrors," a far cry from

Holy Hotrod! (top)
Take an old 1937 Ford, plop in an oversized 1953 Mercury engine, and watch the birth of what *American Heritage* magazine termed the "supreme folk art of the American century." Mike Wall drove this 1950s vintage hotrod built in Holmen, Wisconsin.

Number 12 (bottom)
Hotrod builders typically took old car bodies, in this case an orange 1938 Dodge coupe, and wedged in a newer engine, here a 327 Chevy. Greg Berry restored *Number 12*, driven by Al Pederson in 1956.

the daredevil racers that inspired them. The Prowler officially ended production in 2002.

Chicano lowriders were born in Southern California in the early 1970s. The goal wasn't speed, but to cruise through the streets as slowly as possible, as though out on an evening stroll through a Mexican town square.

Taking a cue from hotrodders, these *carros bajos* were often chopped (the roof lowered), channeled (the whole body of the car dropped down on the frame), and sectioned (a horizontal strip of the car removed to make the whole car ride closer to the ground). Airbrushed murals (in Mexican themes such as the Virgin of Guadalupe), whitewalls, gold accents, and chrome spokes adorned the outside. Wood-grain panels, velvet or leather upholstery, chain-link steering wheels, and the mandatory fuzzy dice enhanced the interior. Subwoofers provided the soundtrack to turn heads and cause ears to be covered. LED and neon lights, operated by computers, have further tweaked the experience.

To make sure that no one missed these slow-and-low lead sleds, hydraulic suspension was soon added. While waiting for a green light, these custom cars performed tricks like corners (lifting one corner of the car), front-backs (jumping from the front to rear tires), and pancakes (raising the whole shebang).

While cars were lowered, trucks were raised. Reverb-filled announcements of "Power! Power!! POWER!!!" in the late 1970s promised mud-slogging, tractor-pulling, fire-spitting monster trucks. Suddenly, all-star wrestling seemed positively wimpy. The first big monster truck event was in the Pontiac Silverdome in 1982, when Bob Chandler drove his beloved *Bigfoot,* with its five-and-a-half-foot tires, right over other cars. The crowd screamed in delight. A long way from county fair tractor-pulling contests, these shows are big business, with celebrity hosts, swimsuit models, and Mud! Mud!! MUD!!!

Monster Car (top)
Ed "Big Daddy" Roth–inspired products such as T-shirts and model car kits sold in the millions in the 1960s. Blue Genie Art styled the Monster Art Car after a Big Daddy Roth model kit, designed for GSD&M advertising for the Orange Show's Houston Art Car Parade.

Flaming Purple Jesus (bottom)
1934 Ford three-window coupe with a 327 engine is the pride and joy of Eugene "Porky" Scharffbillig of Oakdale, here on a Saturday night cruise. Flames by Scott Berosik of Pro Art Custom Paint & Grafix.

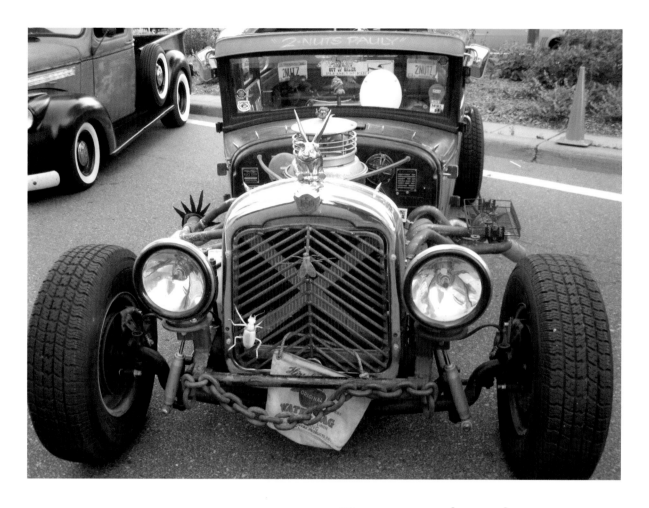

Ratrod
2-Nuts Pauly (aka Paul Gewecke) put this rude, crude, and socially unacceptable ride together from a 1928 REO Flying Cloud for the ultimate ratrod. The bumper consists of welded rusty chain, the grill is rebar, the hood ornament is a chromed flying pig, and, yes, those are toilet seats.

"A teenager always has resentment to adult authority. And they want a better car. They don't want an old man's car."

—Ed "Big Daddy" Roth

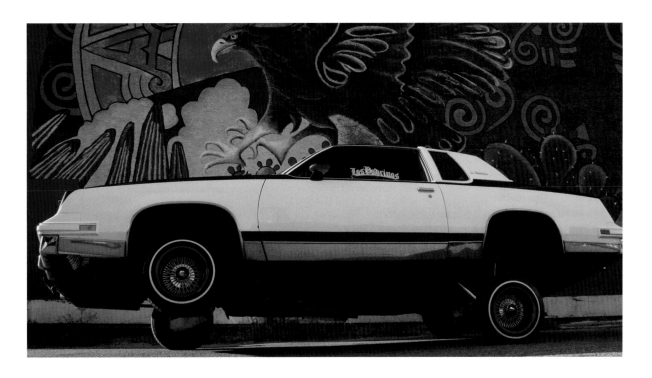

Get a Leg Up (above)
A 1984 Cutlass Supreme white lowrider, with brown trim and red wheel rims, corners with its left front wheel up. Brent Wasieleski of Los Padrinos Lowrider Club performed in front of a west side mural, St. Paul, 2008. *Courtesy of Los Padrinos*

Bling (left)
Jeweled center caps honor hard-working axles. Lowriders have been known to break axles from the wear and tear of cornering. One of Brent Wasieleski's ruby-trimmed Cutlass wheels. *Courtesy of Los Padrinos*

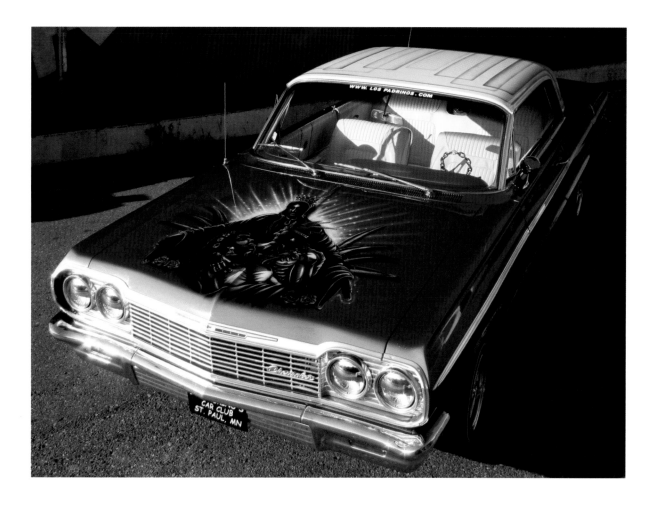

Classic *Carro Bajo* (above)
A painting of the Virgin Mary and the tragic Aztec lovers adorn the hood of Pete Salas's classic Chevy *carro bajo*. Features include a chrome chain steering wheel, sparkle blue paint, and matching chromed hydraulics in the trunk. *Courtesy of Los Padrinos*

Ten Pin Truck (top right, opposite page)
Free twelve-pound balls from bowling alleys spurred Allen Christian's sculpture obsession: forming these balls into bizarre busts. His studio, where he employs power tools to grind faces into the bowling balls, became The House of Balls. His daily driver pickup became a bowling mobile, but was recently destroyed by a driver who'd been tipping back one too many.

In 1949 bowling aficionado Mike Skrovan turned his 1936 Studebaker coupe into a bowling pin car—and just hoped that no one made a bowling ball car to strike him down. Today, the mobile pin rests in the basement of the International Bowling Museum in St. Louis.

North of Missouri's bowling mecca, Allen Christian became obsessed with sculpting bowling balls in the early '80s. "I just call up bowling alleys for balls and I leave with a truckful," Christian claims. "I've got bowlers that come to drop 'em off, but I can't even use them all." He puts on his air-filter mask and grinds the balls into eerie busts, even though he claims that "the balls are probably repositories for nuclear waste."

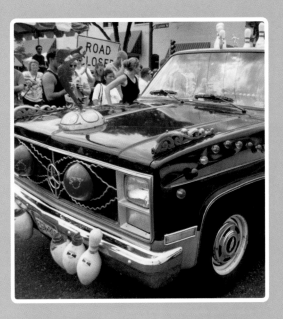

Red-and-white pins dangle precariously from the ceiling as though ready to bop visitors who visit his House of Balls studio in downtown Minneapolis. Even Christian's pickup truck has been the victim of his bowling obsession, as it is adorned with red plastic bowling pins and House of Balls written along the side in red shoe soles. He's driven the bowling truck across the country, but "only in Minneapolis have I been ticketed. Cops hate the red lights on it, as if only their cars can have red lights." Alas, a drunk driver plowed into his parked art truck, leaving Christian no other option but to decorate a classic pickup with his ongoing bowling art.

Bowling Pin Car, St. Louis, Missouri (bottom right)
Just as bowling bag makers copied auto interior design with vinyl GTO Black bags with racing stripes for the muscle-car speedsters, so did bowling aficionado Mike Skrovan pay homage to automobiles with this 1936 Studebaker coupe. He altered it into a bowling pin car, which rests in the basement of the International Bowling Museum in St. Louis. *Courtesy of the International Bowling Museum*

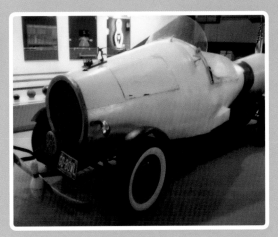

Reinventing the Wheel

Artists slave away for months on one-of-a-kind cars. Like two women who wear the same dress to a party, many art car artists unknowingly work on similar themes. However, they put their own twist on topics, so similar ideas result in varying interpretations. Who knew there could be *two* Mondrian cars! One seems to be a homage to the artist, while the other is a protest against that same artist and the rigidity of the modernist canon.

Morgan L'Argent took a sullen-looking piece of second-hand furniture and made fun of couch potatoes everywhere by taking his remote control couch, matching ottoman, and a jumbo box of chips to the street. Little did he know that an Indiana company called Armchair Cruisers builds drivable couches, sofas, and armchairs in either electric- or gas-powered models, complete with your company logo. A gas-powered loveseat built by the "ChairMan," Daniel L. Helton, will set you back $7,995.

Certain historical moments give rise to contexts that lend themselves to certain material forms of expression. For example, grass and produce cars seem to have been part of the earliest midwestern car parades celebrating hearty pioneer sodbusters and farmers' bounty. Earth Day celebrations began in 1970, and in 1978 Stanislav Tuma of Denmark covered a VW Beetle in live, green-growing sod. By the time artist Gene Pool grew grass from seed on a car in the 1980s and on a city bus in the 1990s, this concept had become a surreal spectacle of rolling Chia Pets mocking the lack of greenery in the urban setting and the modern disconnect from nature. The bus was commissioned in 1996 to draw attention to the fact that real grass was back at the St. Louis Cardinals' ballpark. In contrast, Astroturf was the modern answer to keeping sports fields and the domestic lawn forever green.

In an original twist on unoriginality, Ken Gerberick of British Columbia created *Referential Wagon* (aka

Plaid Car (left)
Tim McNally spent more than a year customizing and painting this 1985 Buick Skyhawk plaid. It only took the New Jersey State DMV three years to make the change to "plaid" on the auto's registration. The *Plaid Car* is on exhibit at the Art Car World Museum in Douglas, Arizona. *Courtesy of Tim McNally*

Geo Chalker
(bottom right, opposite page)
On the back of Neal Spinler's car is a container of chalk with a sign stating, "Anyone that walks by the Geo (while it's parked) is welcome to leave a bit of art on it." *Courtesy of Neal Spinler*

Copy Cat), a Ford Econoline van with pieces of thirty different designs from *other* artists' art cars affixed to its sides. The quoted cars include *Camera Van, Cork Truck, Volvo with Green Gears, Truck in Flux,* and many more. If imitation is the sincerest form of flattery, Gerberick perfected the art with this mimetic mobile.

Illinois Valley Community College in the town of Oglesby stages an annual Edible Car Contest with help from a National Science Foundation grant and sponsorship from the Occupational Technologies Division of the college. Entries must look like cars, have two axles and at least three wheels, and everything must be entirely made from food items edible by humans. Entries must roll down a three-foot-long ramp.

While numerous boat floats can be counted all the way back to the 1920s, artist Seth Weiner has a goldfish at the wheel, or in this case helm, in a conceptually sophisticated project. *Terranaut* involves a fishbowl

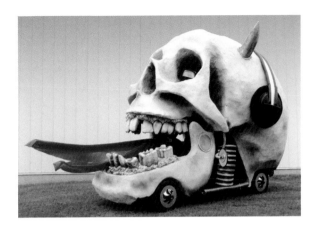

To Drive or Not to Drive (top right)
The difference between a commercial vehicle and one made by independent artists is the freedom for artists to make whatever pops into their skulls. The creator of this *Skull Car*, Greg Metz, lectures at the University of Texas at Dallas, where he and his art students make award-winning art cars.

Copy Cat **by Ken Gerberick** (middle right)
A Ford Econoline van, aka *Referential Wagon*, has pieces of thirty different designs from *other* artists' art cars, including that of one of the authors. Assemblage sculptor Gerberick, of Vancouver BC, is one of the directors of the ARTCAR Society of Canada.

and its aquatic occupant on wheels with a computer monitoring the movements of the fish. The computer "reads" the activities of the fish and interprets which direction it wants to go. The fish gets to go for a ride, as it were, driving itself in its mobile home.

Guy Seven frets about modern technology and its concomitant advancements toward war and nuclear destruction. *Duck and Cover* is a big green 1973 taxi outfitted with bombs and warnings about an impending radioactive apocalypse. "Early one morning I heard a voice in the gas tank telling me to drive a big green car because war is bad for children," says Seven, who is an artist and industrial engineer.

Bill Viereck decided to bring minivans into the space age. Director of Shuttle Van Flight Operations in Eureka Springs, Arkansas, he sees to every detail of the soccer mom's modified modern mode of transport. The technical marvels on the 1996 Dodge Caravan include a 42-inch tailfin, 3,600 hand-painted tiles, three thruster cones, a fog machine, strobe lights, and a computer-controlled console in the command module.

Dying to see the future, art car visionaries in Nebraska took an old ambulance as a cryonic laboratory. Freezing the dead in liquid nitrogen banks on a hope that scientists will devise a way to restore life. *Ambulance to the Future* (aka *Alien Autopsy*) is a sci-fi-themed hearse by Peter Lochren from Omaha and comes complete with an alien in a glass oxygen chamber/coffin, viewable from outside the vehicle. Lochren and his partner, Christine Walker, dress up in tinfoil alien helmets to startle traffic in Nebraska and while on tour to rallies across the country. Yet another UFO zooming through America's heartland.

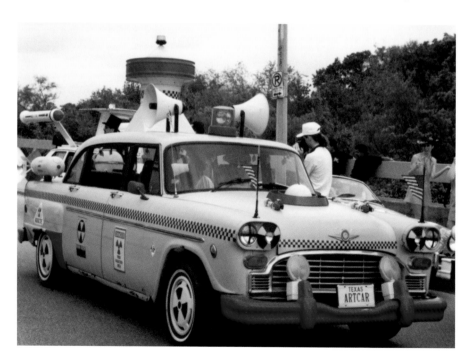

Guy Seven,
Duck and Cover
A big green 1973 taxi outfitted with bombs and warnings about an impending radioactive apocalypse makes its way through the Orange Show's Houston Art Car Parade.
"Early one morning I heard a voice in the gas tank telling me to drive a big green car because war is bad for children," says Seven, who is an artist and industrial engineer.

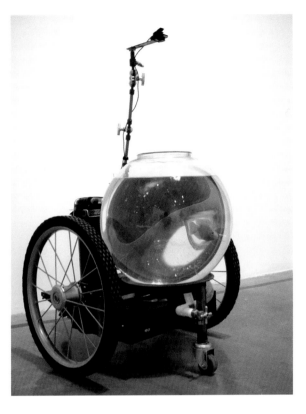

Ready for Warp Speed (bottom left)
Hugo Barrera's *USS Enterprise* challenges the laws of physics to find strange new worlds at the 1997 Orange Show's Houston Art Car Parade.

ShuttleVan (top left)
Bill Viereck, director of ShuttleVan Flight Operations in Eureka Springs, Arkansas, sees to every detail of the modified minivan's technical marvels. The space-age effects include a 42-inch tailfin, 3,600 hand-painted tiles, three thruster cones, a fog machine, strobe lights, and a computer-controlled console.

Terranaut by Artist Seth Weiner (above)
Terranaut is driven by a peripatetic goldfish inside the fishbowl. The computer monitors the movements of its aquatic occupant on wheels and interprets which direction it wants to go. The fish takes a stroll, as it were, driving itself in its mobile home through new spaces, boldly going where no fish has gone before. *Courtesy of Seth Weiner*

RECURRING THEMES

Artists rely on originality to gain credibility, but what happens when a supposedly unique design has been done before—unbeknownst to the owner? Is the artwork a fraud? Is the copycat artist a charlatan? Before art car artists throw barbs over who was the very first, consider how many fruit bowls and naked ladies painters have daubed over the years. Here are some of the perennial favorite art car muses:

- Zebra stripes and leopard skin (camouflage)

- Boats (some actually float)

- Dolls (give Barbie a real Dreamcar to ride around in)

- Flowers (petal power and hippie vans)

- Plastic toys, plastic fruit (why settle for one hood ornament?)

- Food (especially oversized eating items, big tomatoes, ice cream cones, beer cans, coffee cups)

- Shoes (McDonald's has a giant red clown shoe for the Ronalds to ride)

- Circuit boards, cast-off technology (how many years to the iPod mobile?)

- Wood paneling (think woodies on steroids: driftwood, bark, even viga poles through the roof of the cab in an adobe truck)

- Retro (there are several Batmobiles and Scooby-Doo Mystery Machines)

- Chalkboards (local hardware stores have a special paint that will make any surface into a chalkboard)

- CDs, mirrors/reflectors (modernist glass and steel skyscrapers made mobile)

- Couches, Barcaloungers, La-Z-Boys, easy chairs (Barcalounger hired Raymond Loewy of Greyhound bus–design fame to envision the designer recliners of the 1960s, so putting the comfy seats back on the road is fitting)

- Astroturf/grass and plant themes (motorized nature)

- Aliens, sci-fi, spaceships (or are they real aliens disguised as art cars?)

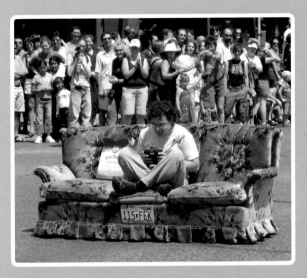

Sweet Ride (above)
Gita Ghei created *La Dolce Vita* to attract
paparazzi to this candy-corn car confection.
No, the sugar doesn't dissolve—unless it rains.
Courtesy of Ericka Bailie-Byrn

Couchmobile (above)
Morgan L'Argent took a sullen-looking piece of
secondhand furniture and made fun of slovenly
couch potatoes everywhere by taking his
remote control couch, a jumbo box of chips,
and matching ottoman to the streets for the
2006 Art Car Parade. *Courtesy of Mike Woods*

Spring Car (opposite page)
Springs of every shape and size are attached to
the car of New Yorker Alan Bolle to form a sort
of wiggly metallic sea urchin come to land. Kids
love to "play" his BMW, as the springs double
as musical instruments. Bolle sports springs on
his fingers, clothes, a hat made of springs (also
an instrument), and he even made a Spring Cow
for the popular Chicago Cow Project of 1999.

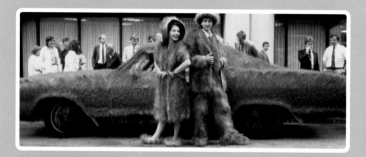

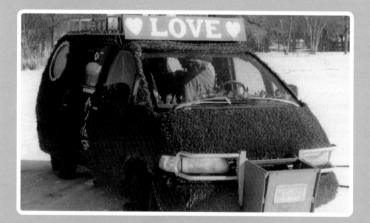

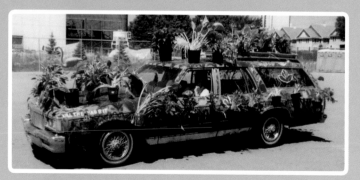

Gene Pool
While environmentalists tout green roofs on buildings to squelch greenhouse gases, artist Gene Pool covered a '66 Buick with lush turf and watered it every night. The car comments on contemporary lack of urban green space. He appears here with Nancy Stark in living grass garb. As a promotion for the return of a real grass field for the Cardinals baseball team, Pool covered an entire St. Louis city bus with grass to entice fans to the park.
Photograph by Gary Sutton, courtesy of Gene Pool

Turf Mobile
Ephraim Eusebio and daughter Lily dispense free-hot-coffee love on top of icy Medicine Lake in 2007.

***Hosta la Vista* by Bernard Gonzalez**
While rust is the nemesis of the average car, this parade entry at the 2003 Wheels as Art festival proclaimed a fear of rabbits and slugs.

Ambulance to the Future,* aka *Alien Autopsy Hearse (top, opposite page) Peter Lochren and Christine Walker host The Central Art Car Exhibit & Celebration annually in Omaha, Nebraska, and often drive up to the ArtCar Parade in Minneapolis in their alien craft. It's a futuristically airbrushed hearse conveying a glass-encased alien. *Courtesy of Bryan Kennedy*

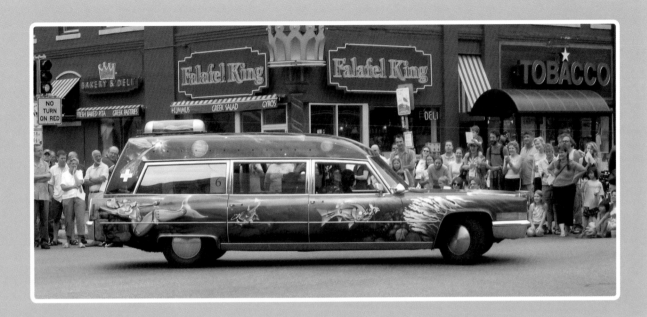

Dig that Edsel! (right)
This Edsel/bulldozer/backhoe from SpawMaxwell construction company of Houston, Texas, makes the rounds at the Adolphus Children's Parade, Dallas, Texas, 2007. Patrick Stanley, Walter Mooney, and Don Fernbach gleefully grafted bulldozer caterpillar tracks, a backhoe, and a front-end loader onto a mustard yellow 1958 Edsel for a parade vehicle that actually works at attracting attention for their construction business. The 351 Windsor engine from a 1979 T-Bird runs on propane! *Courtesy of Steve Reisman*

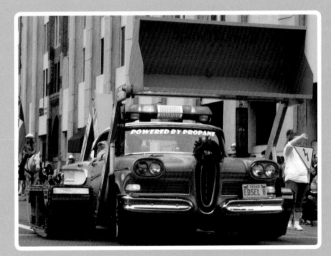

Leopard Car Safari (top left)
Two leopard cars face off at the 1997 West Fest in San Francisco. *Leopard Bernstein* by Kelly Lyles of Seattle stalks behind an unidentified feline vehicle.

Leopard Bernstein (bottom left)
This big cat car is the work of Kelly Lyles. Lyles maintains an informational e-mail service for approximately 400 art car artists nationwide. Her license plate reads GRRRAFX. *Courtesy of Sam Parsons*

Carma Carmelion (right)
Shawn Allison's car is covered in plastic lizards and topped by a plaster torso holding a reptile in each hand. He keeps a treasure chest of toy bugs, rubber lizards, and plastic snakes in his trunk to hand out to curious kids.

Toyboata

Matt Slimmer's street-legal Toyota-boat hybrid at the 2007 Maker's Faire in Austin, Texas, is fully equipped with orange life vests. This boat car makes an early appearance in the 2001 film *Waking Life,* setting the surreal tone for the movie. Most film fans are unaware that the hallucinatory vehicle actually has a real-life existence.

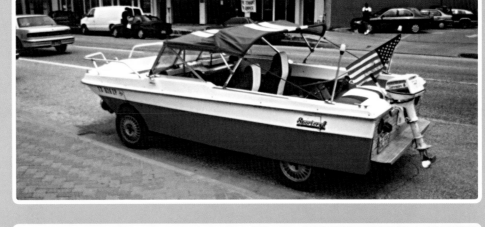

Land Ahoy!

This boat car isn't a boat at all, it is merely a 1952 Fiat 1100 car convincingly shaped like a boat to advertise a sailing school in Bologna. *Courtesy of the Louwman Collection*

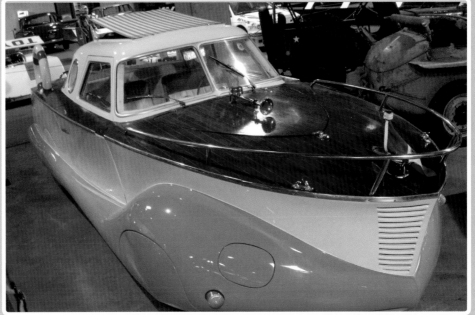

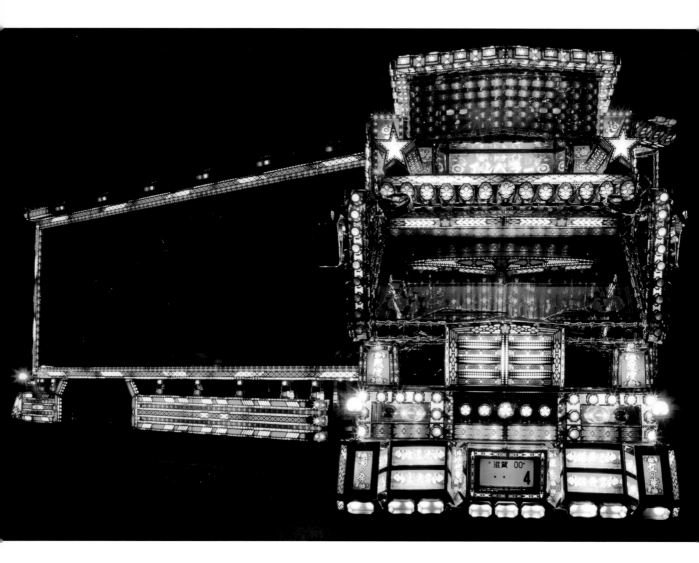

Midnight Emperor

Decotora are Japanese work trucks decorated with the flashiest paint jobs, fully accessorized in lavish chrome and neon. The *Midnight Emperor* lights up Shiga, Japan. *Photograph by Masura Tatsuki, courtesy of Tai Gallery*

**So Many Collectibles,
So Little Space**
(inset, opposite page)
This is the bumper of a quintessential collector car—*Claire*, by Jason Leannah.

WHEELS AS ART

Art car artists drive their messages around town, mocking or celebrating cultural icons and inserting anticorporate ideas into public spaces. French social critic Jean Baudrillard thought that a revolutionary symbolic exchange might be possible through poetic and creative acts that disturb the business-as-usual demands of capitalist production and consumption. For some auto artists, their vehicles are an attempt to insert meaning into the vast barren sameness of a parking lot full of anonymous, equally soulless, mass-manufactured automobiles.

Symbols and Signs

In consumer society, according to Baudrillard, the media takes on an increasing role in presenting the audience with endless decontextualized images, spectacles, and displays, mesmerizing and narcotizing the viewer to the point where meaning and reality disintegrate. Often we are dazzled by spectacle and don't realize the absence of meaning. Art cars are made for display, are spectacles unto themselves, but are not produced by corporate means. They sometimes baffle fellow commuters unaccustomed to a black sheep in the herds of identical automobiles clogging the highways.

Some artists alter their cars specifically to play upon media norms and disrupt expectations about public images. Graphic design firm Thonik, based in Amsterdam, won the Design Prize Rotterdam 2007 with its campaign for the Socialist Party of the Netherlands. The campaign included a fiberglass mobile soup kitchen shaped like a giant squashed tomato and painted red, the traditional Communist color. The fiberglass tomato opened up to reveal burners and cooking equipment. The soup wagon, titled *Soepexpres*, was built by Atelier van Lieshout and offered a designer soup, which was vegan and halal diet–friendly, created by Chef Johannes van Dam. Incidentally, the red tomato has become the Dutch Socialist Party symbol as both an icon of growing fruit and the classic critic's weapon of choice to hurl at corrupt politicians.

Other art cars dedicate their mobile masterpieces less to a single political party, and more to a cause. Lois Piper drives her colorful *Peace Mobile* with a bumper sticker that asks "Who Would Jesus Bomb?" And as though promoting free love, Granny Hug-a-Bug (aka Mary Franssen) on her clown scooter gives out hugs and hands out tickets entitling anyone to give anyone else (who is willing) a free hug. A car covered in plastic toy bees sports a grass skirt and the message that the bugs are beneficial to the environment. Mina Leierwood, grade-school teacher, activist, and creator of many art vehicles, made a polar bear car to publicize the plight of that endangered species. The car's plates read XTINCT, and the artist wears a white bear costume when appearing in parades.

For a constantly changing canvas of political ideas, Margaret Miles and Cathy ten Broeke use Magnetic Poetry to make an interactive work of art out of their van. *Free Speech Car*, unlike many museum pieces, encourages the public to touch and rearrange the art to suit themselves: leave your own message to share with the public. The artists generously take the message with them wherever they drive.

Ben Cohen, cofounder of Ben & Jerry's ice cream company and president of Business Leaders for Sensible Priorities, commissioned art car artist Tom Kennedy to make the *Topsy-Turvy Bus* in 2007. *Topsy* is two mini–schoolbuses welded together, one upside down on top of the other, to "dramatically depict America's upside-down budget priorities." Pie charts illustrating the federal budget's tiny sliver to education and massive dollops for the Pentagon adorn the sides of the surreal yellow upside-down cake. Cohen may owe his financial success to clever corporate marketing, but, he says, "I'm a guy who's been looking to use art cars for social change, and Kennedy is a guy who wants to make art cars for a living with some social purpose. Clearly, we were both searching for each other."

**Soepexpres, Mobile
Soup Kitchen** (right)
Soup Express was designed
by Thonik and built by
Atelier van Lieshout for
the Socialist Party of the
Netherlands, Rotterdam.
Shaped like a giant tomato to
hurl at lousy politicians, this
red vehicle also dispenses
hot soup to the hungry.

Give Bees a Chance
(opposite page)
Anne Chenette's car,
covered in plastic toy
bees, sports a grass
skirt and the message
that the disappearing
bugs are beneficial to
the environment.

**Topsy-Turvy Bus
by Tom Kennedy** (right)
Topsy is two mini school
buses welded together,
one upside down on
top of the other, to
"dramatically depict
America's upside down
budget priorities." Ben
Cohen, cofounder of
Ben & Jerry's ice cream
company and president
of Business Leaders
for Sensible Priorities,
commissioned the art bus,
which tours sites of major
political rallies and events.

Auto Archetypes

In earliest transport, having a beast pull your cart instead of you having to slog behind the wheelbarrow was a status symbol. Owning a fine team of strong oxen or a fast-pulling horse was a sign you had done well in life—an early version of a muscle car to impress the ladies. The first autos were sold by bragging that you never had to feed them (gas shortages of today not envisioned), and they never got tired.

Cars are animals of a sort: they move, sometimes with minds of their own, they are our beasts of burden, we enjoy riding in them and spurring them to go ever faster. Some drivers treat their rides like pets or family members: relied on, cosseted, cursed at, and ignored until needed. We build little houses for them near our own to protect them from the elements. In the Roaring Twenties, a raccoon tail was an ornament of choice for a flivver. Lucky rabbit-foot tokens are hung from rearview mirrors and adorn keychain fobs. Esso gas promised to put a tiger in your tank. Thus animal-car hybrids are not particularly surprising as a category of art car. What is surprising is

Faith
Prolific car artist David Best challenged the definition of a centaur with his animal-car hybrid, which now basks in the limelight of a museum. *Courtesy of the Art Car Museum*

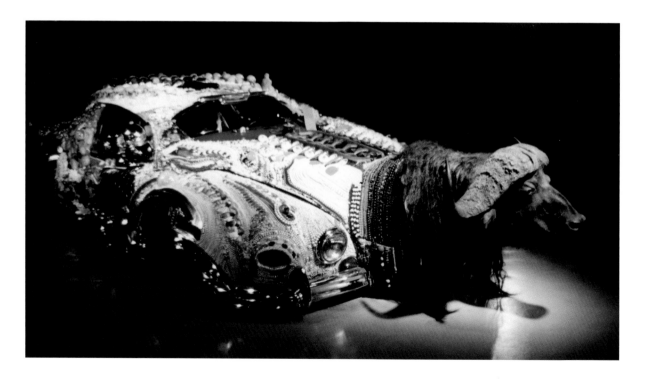

the heights to which animal totems have been affixed to and incorporated into artistic visions of transport.

Faith, by prolific art car artist David Best, is an accumulation of beads, trinkets, castoffs, and toys topped by the stuffed head of a Cape buffalo on the front bumper. A magnificent specimen of auto architecture, it is now housed in the Houston Art Car Museum. L. Frank Baum, in *The Marvelous Land of Oz*, a 1904 sequel to *The Wonderful Wizard of Oz*, envisioned a winged conveyance made out of castoffs brought to life by means of a magical powder. Called the *Gump*, it had an ill-tempered talking trophy-animal head that let the thing know where it was going.

> "Cars are often depicted as extensions of the human body, their rounded roof lines and fenders evincing biomorphic visual rhymes with a character's fedora or boxy suit."
>
> —Paul Arthur, in *Inside Cars*

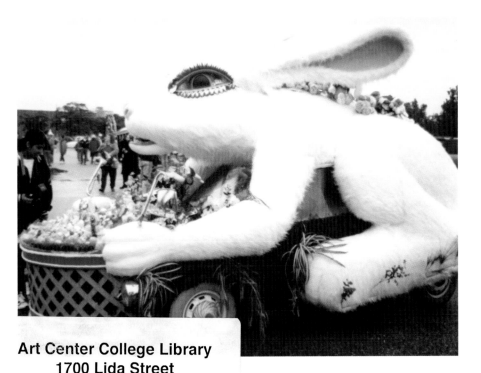

Bad Hare
Bayou Bunny
Mendocino-based sculptor and inspiration to a generation of art car artists, Larry Fuente has work on display in the Renwick Gallery of the Smithsonian. In a feat of understatement, curators there cite his work as "related to a Latino popular-culture tradition in which automobiles and other objects are embellished with a profusion of brightly colored ornaments." Here his *Rex Rabbit* gets ready to hop on its hydraulics.

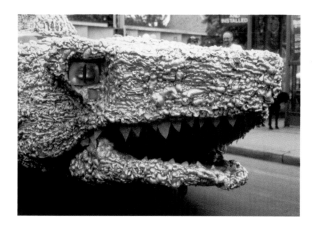

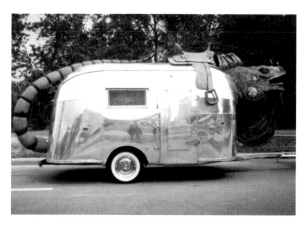

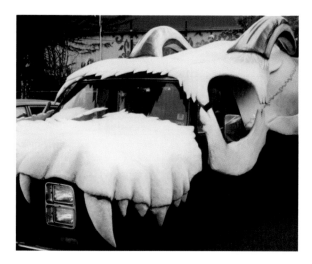

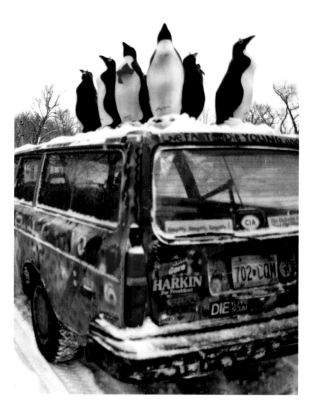

Animal Migration (clockwise from top left)
Ripper the Friendly Shark by Tom Kennedy; *The Skull*,
a fragile papier-mâché truck built by Julian Stock, a
Mardi-Gras float maker; *Too High, Too Wide & Too
Long, A Texas Style Road Trip* documents Bob Wade
and his *Iguana Mobile*. Copyright bobwade.com, used by
permission; Penguins stick out from an inland iceberg
cruising down snowy streets with creator Bill Stryk.

Auto Architecture

Making your own spectacle is a subversive act in a culture that sets the hierarchy of value according to sticker price and indoctrinates its members that having a less-expensive car makes you less desirable as a person. Even children too young to drive are taught which cars are valuable and worth gawking at, through toys, model cars, video games, and commercials. Art cars distort the idea of value. Many artists tell how spectators inquire if the artist is worried that the resale value of the car will plummet because of those Pez dispensers glued all over it.

This is an odd thought. Historically, art making can actually create value in society. After all, a Matisse is worth more than the cost of the paint and canvas; a Michelangelo statue is worth more than the chunk of marble. It's fairly certain no one ever asked Matisse to be concerned about depreciating of a new canvas by mussing it up with paint or warned Michelangelo to be careful not to ruin those rocks.

It is precisely the utilitarian trade-in value of a vehicle that gets regular consumers riled up over the affront of an art car. One of the taboos being broken is the disruption of the trade-in and trade-up system. Art cars exit the normal consumer stream and have to be valued on different terms. Or as a 1996 Mercedes advertisement asks, "Would you describe a Picasso as secondhand?" If they are ever sold, they must be bought by someone who *likes* bowling balls, plastic fruit, or Mardi Gras beads enough to drive them around on continual display. Plus it is just plain fun to be released from the stress of dents, scratches, depreciation, and other petty annoyances plaguing the average car owner.

Mercedes Bonz is an example of a Volvo remade into a Mercedes via an act of art. A grade-school principal who always wanted a Benz but could only afford a

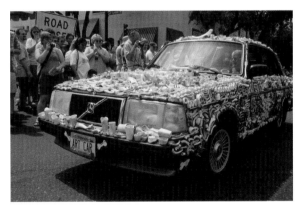

Mercedes Bonz
B. J. Zander covered a Volvo with bleached bones to honor Mexican Day of the Dead traditions, in which life and death are inextricably linked.

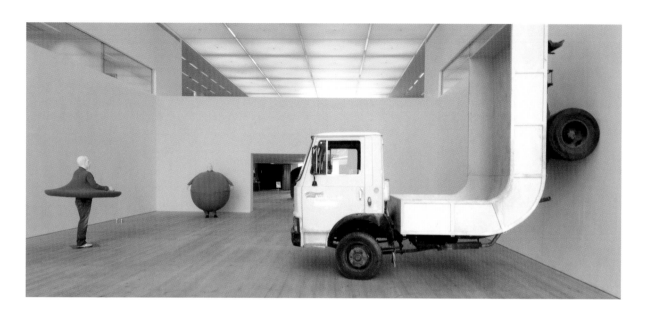

Erwin Wurm, *Bent Truck* (above)
Wurm creates another surreal object masquerading as plausible at first glance while ultimately utterly rejected by the rational mind. The art takes place conceptually in the mind of the viewer, who is forced to think about the impossible object in use.
Courtesy Galerie Krinzinger and Galerie Xavier Hufkens, photo by Colin Davison. © BALTIC / the artist, courtesy of BALTIC Centre for Contemporary Art

Livio De Marchi (left)
A maestro of hand-carved trompe l'oeil sculpture, De Marchi drives his all-wooden Ferrari F50 through the canals of Venice and under the Bridge of Sighs. *Courtesy of Livio De Marchi*

modest schoolmarm's Volvo covered her vehicle in bleached animal bones in homage to the Mexican Day of the Dead celebration. Thus *Mercedes Bonz* emptied the sedate Volvo of its original meaning and filled it back up with a wild, even dangerous-looking, exciting new persona given to it by the artist B. J. Zander. Art has a rare ability in consumer society to create something highly valuable out of waste products and scrap material, far surpassing the sum of the cost of the original parts.

Livio De Marchi is an Italian maestro of hand-carved wood trompe l'oeil sculpture. His intricately detailed renditions of objects in a material unnatural to their normal existence causes instant surprise and delight. He will put an object rendered in wood in a new context that is even more stunning, such as motoring his all-wooden Ferrari F50 through the canals of Venice. Even the seats, interior, and wheels are carved in superb, lifelike detail. In 1994 he made a floating wooden Cinderella pumpkin coach, able to accommodate four riders and complete with four life-size horses, now owned by a Ripley's Believe It or Not! museum. Titled *A Dream in Venice,* it was ridden through the streets and driven in the canals at Carnevale, the ultimate magical parade spectacle.

Erwin Wurm, noted previously, has made works that defy logic and force the audience to reimagine common consumer items in extraordinary ways. *Telekinetically Bent VW Van* was the outcome of Wurm's correspondence with a yogi who claimed to be able to bend objects with his mind. The VW is indeed bent, it could only possibly drive in circles, but how that actually came to pass remains a secret between artist and mystic. *Bent Truck* is another impossible object masquerading as plausible at first glance while ultimately utterly rejected by the rational mind. Like all good surrealism, the art takes place conceptually in the mind of the viewer, who is forced to think about the impossible object in use in real life.

Some art cars have ended up in museums, while most others quietly end their lives at the junkyard. The value to the artists isn't necessarily monetary, but an intangible value, such as creating and declaring one's identity, control over one's own image, getting a "show" regardless of a gallery's backing, public recognition, bonding with a community, the joy of self-expression, and the generous impulse to give pleasure to the viewer.

A few bona fide famous artists have been commissioned to paint limited-edition cars for manufacturers. Roy Lichtenstein painted his trademark benday comic-strip dots on a LeMans race car in 1977. The BMW company has an art car collection consisting of a series of "production models transformed from automobile to art by some of the world's foremost artists," including Alexander Calder, Andy Warhol, Frank Stella, Robert Rauschenberg, David Hockney, and Jenny Holzer. BMW hyped this artistic firestorm in ad copy "to the discerning motorist, who wants to express his individualism," never actually managing to produce these cars for the consumer market.

Such cars aren't strictly promotional vehicles, since the artists aren't restricted to advertising images and in fact are expected to make trademark stylistic references to the art that made them famous. In 1991 Esther Mahlangu, a South African painter from the Ndebele tribe, was commissioned by BMW. Traditionally, Ndebele women decorate the outside of their homes in bold geometric patterns, and Mahlangu drew upon these striking motifs to cover a 525i saloon car. Without ever making these cars available for sale, BMW enhanced its company's image as a tastemaker and arbiter of high style by investing in these one-of-a-kind artworks.

When philosopher Roland Barthes compared modern automobiles to Gothic cathedrals, he declared that cars are "the supreme creation of an era, conceived

LeMans by Lichtenstein
BMW commissioned the pop artist Roy Lichtenstein to paint his trademark benday comic-strip dots on a LeMans race car. The car is a one-of-a-kind piece; the car company kept it in its private collection.

Esther Mahlangu, South Africa
South African Ndebele tribeswomen paint the outside of their homes in bold geometric patterns. Esther Mahlangu drew upon these striking motifs to cover a 525i saloon car for the BMW Collection.
Courtesy of the National Museum of Women in the Arts and BMW

with passion by unknown artists, and consumed in image if not usage by a whole population which appropriates them as a purely magical object."

Barthes's comparison of cars to architecture goes deeper than just saying that cars are the most important artistic invention of our time. The car has become our house in many ways. In the old days of the long bench seat, the car was as safe as being at home, with no seat belts and no need for a baby seat. Teenagers would take advantage of this portable love den at drive-in theaters, and Nash even advertised that its seats all folded down into one large bed inside the car.

Some dangerous drivers eat, drink, apply makeup, shave, and even floss their teeth while behind the wheel. Modern cars have built-in cell phones, Internet access, global positioning devices, and entertainment centers with sound systems and DVD screens in the back for the kids. Not only are cars often more luxurious than homes, they've become the technological showcase to display your wealth of gadgets.

Perhaps Barthes took a cue from Swiss architect Le Corbusier, who shot photos of fancy cars in front of classical monuments to show that the automobile was the cathedral of his time. A 1921 Delage Grand-Sport was photographed in front of the Parthenon in Athens, and a 1907 Humber was shot in front of the Paestum temple south of Naples. "In juxtaposing motor cars and temples, Le Corbusier was advocating a developmental mode for the automobile applicable to modern architecture," according to Tag Gronberg in *Designs on Modernity*.

In 1946 the first mass-produced houses sprung up in Levittown, New York, for GIs returning from the war. Civic planners seized onto the cost-saving aspects of streamlined design from the Le Corbusier school while ignoring humane necessities. The new ticky-tacky houses became a symbol of conformity and soulless functionality in design. While working-class car consumers got a choice of paint color and hubcap dimples, the wealthy always had access to high style. Midcentury designers lengthened the body, vamped up grills, swooped the hips, played with window shapes and the spare-tire well to sculpt a vision of uniqueness in high-end vehicles that were nevertheless factory made. To give personal style to these mass-produced objects—whether a car or a house—owners would have to apply their own artistic flair and risk resale.

Pop Art
Pop artist Andy Warhol painted a LeMans race car for BMW. Unlike the other artist-commissioned BMWs, Warhol painted directly on the car, signing his name in the wet paint. *Used by permission of BMW*

> "I think that cars today are almost the exact equivalent of the great Gothic cathedrals."
>
> —Roland Barthes, in *Mythologies*

Obsessive Collecting

Art car artists both mock the conventions of consumer society by messing with the prized factory finish and participate in them by fetishizing the car as an expression of individuality. Wildly excessive displays of consumer items arrayed on the exterior of collector cars can be an overt form of this dual relationship, both devaluing consumer objects (by gluing them on the hood and trunk) and paying homage to their multiplicity of forms and sheer weirdness. Springs, cameras, corks, bottle caps, stamps, protractors, bones, coins, CDs, tennis balls, singing plastic fish, maps, and even grass have been glued to cars in this attack on conformity and in celebration of acquisitiveness.

Obsessive collecting, while a solitary pursuit in theory, begs for an audience—someone who would never go to the same lengths and depths but can be wowed by the end result. Art cars allow owners' collections to free their stamp albums, bell jars, and dusty cases and be mounted outside in permanent mobile exhibitions.

Collections reveal the person, or at least what he wants to show of himself. The National Association of Collectors' website lists many hundreds of collecting clubs, from the American Hatpin Society to the Dorset Thimble Society to the Egg Cup Collectors of Great Britain. What often starts as a small accumulation can snowball until an artist must figure out what to do with that giant pile of widgets. A person's identity is exposed by what he collects, and art cars might be the perfect solutions to storage and display.

The sheer amount of meticulous labor involved in a collector's art car both satisfies a compulsive artistic urge and impresses the public with the maker's single-mindedness. Broken glass isn't the easiest or safest material to use, yet several artists have risked bad luck and covered their cars with broken mirrors—modernist glass-and-steel skyscrapers reduced to human scale and made mobile. Notably among them is OXO, tag name for graphic artist Robert J. Corbett of Butte, Montana, who made the "world's shiniest oldsmobile" by encrusting his entire behemoth with mirror shards.

Stained glass master craftsman Ron Dolce covered his VW Beetle in glittering mosaic. The work is so seamless, the viewer forgets that the Bug's extreme curves are a difficult surface on which to glue flat glass shards.

Community centers, art schools, and craft camps for children find that the mass gluing of objects to a car presents a way for every kid to participate. They choose a theme and, most importantly, someone donates a car. A completed art car by a group of kids gives satisfaction in a way that few other projects can. Art students at Waltrip High School made a glittering homage to funk musician George Clinton titled *Atomic Dog, One Nation Under a Groove*, and instructor Rebecca Bass managed to send the assemblage mobile to Germany for the Essen Motor Show.

Sculptor Jose Benavides collects materials that society considers disposable and reworks them into art. He riveted blue and white license plates together to form a rolling Madonna car, arms open in the classic statuary pose. "I like taking something that's been discarded and giving it new value by putting it in a new situation," Benavides explained. With a background as an engineer and having an MFA in sculpture, Benavides is not a folk artist nor is he particularly religious. His iconic mobile statue alludes to sources such as Mexican scrap-metal sculpture and devotion to the Virgin Mary, but also outrageous Chicano lowrider style, pop art, surrealism, and postmodernism. The artist rides in the midsection, giving himself a miraculous birth each time he gets out of the driver's seat.

Cigs Kill
Cigs Kill is a 1951 Nash covered in braised copper tobacco leaves, created by Alex Harrah. *Courtesy of the Art Car Museum, photo by T. Mitchell Jones*

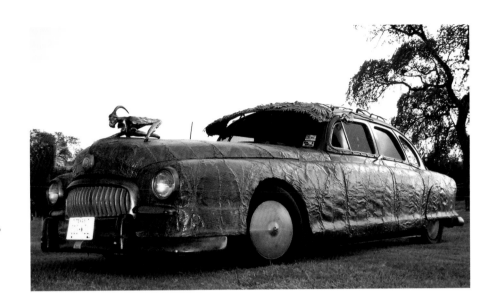

Madonna Car
Sculptor Jose Benavides collects materials society considers disposable and reworks them into art. He used blue and white license plates riveted together to form a rolling Madonna car, arms open in the classic statuary pose. "I like taking something that's been discarded and giving it new value by putting it in a new situation," declares the artist.

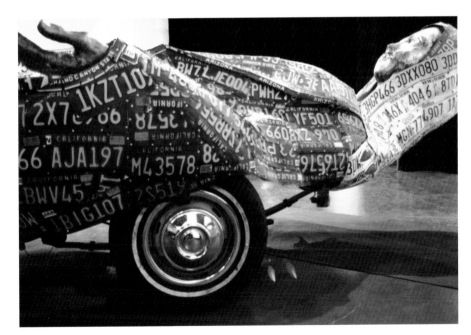

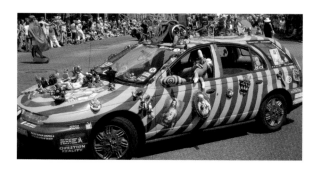

"If your parents loved you,
REALLY loved you, they'd
let you paint their car!"

—Art car artist Dean Raeker,
to curious children

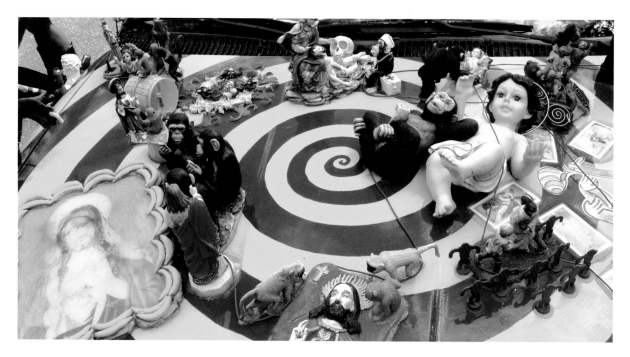

What Would Jesus Drive?
The *Jesus Monkey* car? Even though this car has
two collectibles themes—simians and the Savior—
the artist prefers to ride his banana scooter dressed
as Jesus at the ArtCar Parade. *Courtesy of Mike Woods.*
Detail of *Jesus Monkey* car. *Courtesy of Peter Fleck*

"An art car is often fantasy made
into reality, a symbol of freedom,
and a rebellious creation."

—Harrod Blank

What Goes Around
Jan Elftmann's theme-in-the-round covers her *Holy Circle* car 360 degrees. An obsessive collector, the artist prowls thrift stores for glueable items.

O Happy Day!
The Cabbage Patch craze hit Sheila Burns's car with disembodied babies sprouting across the hood. Cabbage Patch Kids began in the 1970s as adoptable dolls with birth certificates from Babyland Hospital. By 1990, 65 million of the toys had sold, and as with many collectibles, some inevitably are reborn on art cars.

PezCar
Cliff Lee, a self-proclaimed Pezaholic, epoxied hundreds of Pez dispensers to his 1977 Dodge Aspen. New owner and PezHead Gary Plunkett continues the *PezCar* project today.

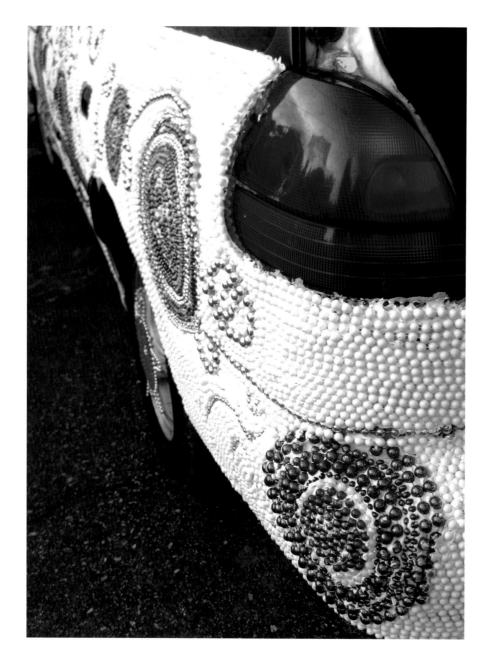

Love Beads
Mardi Gras beads, which are already strung together, are perfect for art car surface design. The strands easily conform to the car-body curves, and beads are weather resistant as well as colorful. Artist Mary Rivard led ArtiCulture community nonprofit art workshops to create this assemblage vehicle.

I Love You This Much (top, opposite page) Mary Alice Rosko spreads the "wuv" aboard her vintage Ford Falcon at the Wheels as Art Parade.

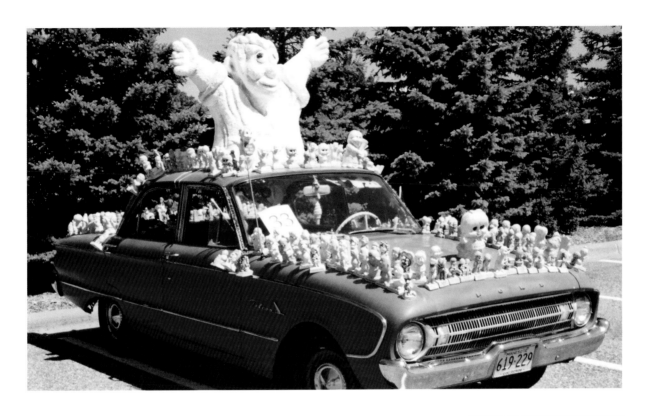

Surfin' Safari by Bellaire High School Students (right) A shark breaches the rolling waves atop this car with a pool in back in Houston, Texas. Rebecca Bass has made many stunning cars with her art students, sometimes touring them internationally.

Many collections consist of dated knickknacks from mainstream culture, and art cars are the perfect repositories for last year's castoffs. *Whip it!* a 1962 Chevy Biscayne covered with Herb Alpert & the Tijuana Brass record covers, used a fittingly retro art technique, decoupage, to hermetically seal the surface of this blast from the past. But recruiting a dark-haired young woman willing to be covered in whipped cream and perch on the hood for a ride down a parade route is not an easy task. Whipped cream easily sours in the hot sun, so Barbasol shaving cream is the artist's coating of choice to re-create the album cover's famous salacious pose.

Vinyl records, now antique media, are still a popular art car material. The plastic tends to melt in the heat of the sun and the motor to conform nicely to the auto's shape. (Remember the old caveat *not* to leave records in the car on a hot day?)

Some drivers cover their beloved cars during inclement weather. Quilters have always collected scraps of fabric, but putting them together for a drivable car covering is a bit more unusual. Fiber artist Ursula McCarty made a car cozy, complete with pink ruffly flounce, while a group of midwestern quilters made a puffy quilt out of fabric scraps. Since some are squeamish about committing to permanently painting or altering their cars, perhaps a removable costume for the auto is the solution.

The Sashimi Tabernacle Choir, created by Richard Carter and John Schroeter from Houston, is a collection of hundreds of mechanical Billy Bass singing fish and plastic lobsters mounted on an old Volvo. Linked to a computer, they rise up and sing in unison, or solo, to tunes such as the "Hallelujah Chorus" blasting out of the speakers.

Strings of Mardi Gras beads lend themselves well to following an auto's surface curvature, and more than one car has been covered with the colorful souvenirs from New Orleans. Action figures make pop-culture fodder for art car makers, as many a McDonald's Happy Meal toy or passé movie superhero doll ends up cheap or

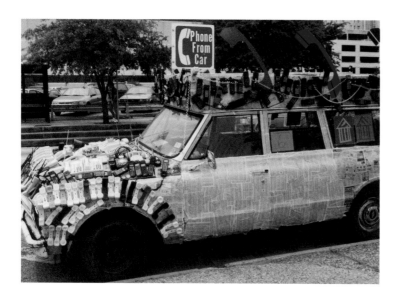

Mobile Mobile (left)
Some mobile phones are smaller, but this one by Karen Nichols boasts a complete assortment of styles and models. Phone from Car sign included.

Modern Dining Is No Fun for the Dinner (opposite page)
Sculptor Greg Metz of Dallas, Texas, remade a 1955 Airstream trailer into an air-conditioned nightmare revealing how meat gets to the table of a modern diner. The other side of the diner features a rendition of DaVinci's *The Last Supper* with Gandhi, Louisa May Alcott, and other notable vegetarians joining Jesus for a meal. *Courtesy of Harrison Evans*

free at the local thrift store. Trophies arrive at the secondhand store by the trunkload. Car owners' minds are put at ease, since these plastic toys and golden bowling champs weather the rain without rusting or rotting.

Art cars have been covered with Sheetrock screws (*Screw Car*); pennies (perhaps illegal since money is legal tender); salmon skin (the fish skin is tanned and "perfectly waterproof, more waterproof than a car," claims the artist); peanut shells (with a plastic illuminated Mr. Peanut on the roof); beans (*Mercedes Beans*); bones (*Mercedes Bonz*); pens (*Mercedes Pens*); plastic lizards (*Carma Carmelion*); reflectors (always be seen); Astroturf (indoor-outdoor protection); cigarette butts (the *Stink Bug*'s a VW Beetle); teeth (*ChewBaru*); and telephones (the *Mobile Mobile* has a Phone from Car sign included).

Glue can be a jealously guarded secret. Heavy-duty epoxies such as Liquid Nails, J-B Weld, or Devcon are usually used. The Internet reveals all, however, as artcars.com features a how-to webpage with advice on glue, paint, pop rivets, and the like. Some artists skip gluing objects and just use adhesive materials for their own unique look, for example the *Duct Tape* Volvo.

At an art car symposium in Houston, art historian Todd Rowan proposed a theory that wearing our identities on our cars might be a means of exorcising our common demons, obsessions, fears, and dreams. Many items found on assemblage cars are icons of popular culture, loaded with meanings, myths, desire, nostalgia, the so-bad-it's-good stuff Americans both love and hate. Some of the items such as teeth or dilapidated stuffed toys are just plain uncomfortable to look at in such profusion, and in such an unexpected context. They become a kind of mobile memento mori. Wearing your issues on your T-shirt has given way to driving them around!

Assortments superglued on the Dodge Darts of yesteryear are quirky identity markers in an increasingly uniform consumer culture. You can't just hop down to the dealer to *buy* a car covered in bottle caps like *Millennium Mobile*, at least until Detroit hires a string of full-time car artists.

"Now ever since I was young, it's been my dream / That I might drive a Zamboni machine," says a song by the Gear Daddies. Ready-made audiences seated and awaiting the main arena events are amused by the sturdy surface-tenders, which come in a wide array of forms. While most Zamboni ice resurfacers are painted with the home team's colors, some inspired Zamboni drivers have become wannabe artists and transformed their beloved machines to look like a stock car, a garbage truck, and even a can of the "miracle meat" Spam for a *Spamboni*. An *AstroZamboni* vacuums water from artificial turf at the Astrodome. The San Jose Sharks' hockey arena Zamboni sports a dorsal fin. Kids trick-or-treat dressed as a Zamboni, and David Letterman raced them down 53rd Street during New York rush-hour traffic. Zamboni ice resurfacers are adorned in black for funeral processions for fellow drivers.

Charlie Brown proclaimed, "There are three things in life that people like to stare at: a flowing stream, a crackling fire, and a Zamboni clearing the ice." That said, who wouldn't want to watch a Zamboni garbage truck? Zamboni Man, Walt Bruley, drives the electric garbage-truck-painted Zamboni at the Duluth Entertainment Convention Center arena next to Lake Superior. "I don't want to say I'm famous," Bruley says, "but whenever I go out to dinner in Duluth someone comes up and says, 'You're the guy who drives the Zamboni, right?'"

This boxy contraption is the perfect canvas for creative minds. They can alter their beloved ice resurfacer to become a St. Louis barbecue smoker or a giant hot tub in the Canadian woods. The French avant-garde musician Jean-François LaPorte used an ice resurfacer as the main instrument of his twenty-two-minute found-sound composition of musique concrète—longer than it takes a Zamboni to clear the ice.

Zamboni Vacuuming the Lawn (opposite page)
An *AstroZamboni* vacuums water from artificial turf at the Astrodome.
© *Zamboni Company Archives*

Montreal Canadiens' Zamboni (right)
Ready-made audiences seated and awaiting the main arena events are amused by the sturdy surface-tenders, which come in a wide array of forms. © *Zamboni Company Archives*

Nonrenewable fossil fuels lead environmentalists to speculate that art cars—or cars of any kind—are going nowhere fast. The September 2007 ArtCar Fest in San Francisco spurned this cynicism with a new contingent of green art cars. Art car artists take all components of the vehicle, even the fuel, as a potential means of expression. Nick Morgen of Santa Cruz converted his 1986 Toyota MR2 into an all-electric vehicle with see-through panels to show off his environmentally friendly machinery. *Does Not Compute* plugs into any standard 110-volt AC outlet and can cruise on the freeway at up to seventy miles per hour. *Eartha Karr*, created by Blake More, is a 1978 Mercedes 300CD running on biodiesel, a nontoxic, biodegradable, carbon-neutral fuel made from recycled vegetable oil.

According to Marjorie Suddard of Grassroots Motorsports, "Biodiesel…is a renewable fuel made from fryer grease…This green fuel is…free of sulfur, and reduces emissions of particulate matter, unburned hydrocarbons, carbon monoxides, and sulfates compared to traditional petrodiesel." Biodiesel can be used in unmodified die-

Green Car
Eartha Karr, created by Blake More, is a 1978 Mercedes 300CD running on biodiesel, a nontoxic, biodegradable, carbon-neutral fuel made from recycled vegetable oil. As early as 1900, a diesel engine was successfully run on peanut oil.

sel-engine vehicles, but the owner may have to clean the car's fuel filter more often. Since many vegetable oils have similar properties to Number 2 diesel fuel, some eco-cars run on straight vegetable oils; or waste vegetable oils, others use a prepared mixture. The emitted odor bears an uncanny resemblance to french fries—imagine future highways blocked during rush hour with exhaust pipes pumping out fryer fumes.

The idea of running engines on anything but refined gasoline is hardly new. Before Standard Oil and other companies decided on a norm for fuel, early motorcars ran on everything from steam to kerosene.

Dr. Rudolf Diesel patented the diesel engine in 1892, and at the 1900 Paris World Exhibition the French Otto Company demonstrated a smooth-running peanut-oil-powered diesel engine. Electric cars are not new, either. Small electric vehicles predate Benz and Diesel internal-combustion vehicles. Popular turn-of-the-last-century models included the Baker Electric, Edison, Studebaker, and Detroit Electric, among others. The Citicar commuter vehicle was made as a production vehicle in the United States during the oil crisis of the 1970s by Sebring Vanguard Company. Art cars of the future will be based on whatever forms of transportation evolve.

Bamboo *Bamgoo*
Bamgoo, an electric car with a body made out of bamboo, was developed by Kyoto University students and the Venture Business Laboratory in 2008. The sixty-kilogram, single-seater, ecologically friendly concept car can run for fifty kilometers (thirty miles) on a single charge. *Courtesy of Professor Kazumi Matsushige*

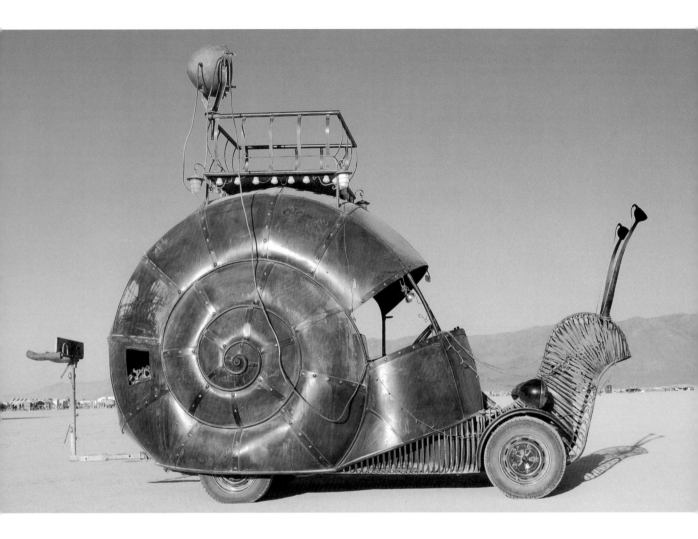

Snail's Pace
Jon Sarriugarte of Form & Reform metal fabricators in West Oakland welded *The Golden Mean*, a Jules Verne-esque riveted snail car with a patinated finish and flamethrower antennae. Crawling on a VW frame, this wheeled slug was launched at Burning Man 2008. *Courtesy of Jon Sarriugarte*

Mobile Museum (inset, opposite page)
FunOMENA—a museum on wheels.
Courtesy of Alan Davidson

ART CAR DESTINATIONS

Hundreds of thousands of owners of trendy sports cars, bought to make them stand out in a crowd, don't appreciate the reminder that they aren't so different. Ironically, in a culture that claims to value individuality, the art car is perhaps too unique. Art cars poke fun at the conceit put forth by advertisers that you are what you drive by demonstrating the constraint that you might be merely what you can purchase.

Midwesterner Eugene Thickening covered his late-model white Cadillac in red reflectors and myriad circular chrome objects and wore polka-dot suits to match. When asked why he'd do that to a new Cadillac, Eugene replied, "Anyone can buy a Cadillac, but now it's the only one in the world!"

In the Southwest, Slim Sirnes devised fantasy sculptures, insulated his house, and made functional objects such as lawn chairs, hats, belts, and purses woven from thin strips of aluminum he painstakingly cut from old soda cans. The material was readily available and had interesting effects depending upon the selection of brand graphics, colors, and patterns. He sold the recycled art out of a pickup truck he partially covered with an intricate weave of metal strips and a can-studded trailer advertising "Pop Art."

Howard Finster, the Georgia bicycle mechanic turned world-famous folk artist, began making art when God spoke to him via a drip of green paint on his thumb. The bands Talking Heads and R.E.M. used his artwork on their album covers, and the "Radio Free Europe" video was filmed at Paradise Gardens, Finster's sprawling, compulsive assemblage folk-art park. His work is included in the Smithsonian, the High Museum of Art, and many other collections. He made more than one art car, and when they wore out he incorporated the carcasses into Paradise Gardens, where they seem to melt into the mosaic surrounds.

As cars became disposable items in the consumer waste stream, artists have found them an interesting and affordable material to remake, quote as icons, or use in installations or site-specific art.

The Heidelberg Project, named for a street in Detroit, is an area of urban decay remade into an outdoor art environment during the course of more than twenty years by artist Tyree Guyton. His use of salvaged toys, vacuum cleaners, chairs, shoes, suitcases, abandoned houses, and cars transformed his blighted neighborhood into an area of hope and pride recognized around the world.

Art Car Museum
The galleries and exhibits of this fun Texas museum celebrate the spirit of post-modern car culture in all its glory. Courtesy of Jason McElweenie

Cadillac Ranch
(opposite page) "Gracefully arched rear fenders," was how Cadillac ad copy lauded it's timeless mobile. *Courtesy of Eric Peterson*

Shake That Tail Feather

Just west of Amarillo, Texas, in the flat fields south of Interstate 40, stand ten Cadillacs buried nose into the ground, tail in the air. Millionaire Stanley Marsh III collected these cars to show the progression of automobile fins on classic luxury vehicles.

Fins were born when Harley Earl witnessed Charles Lindbergh's transatlantic flight in 1927 and we entered the age of the airplane. That same year, Earl formed General Motors' styling section as part of the Fisher Body Division and later became head of GM's art and color department. Earl debunked Henry Ford's philosophy of making the same car ever cheaper so even his own workers could afford one. Instead, consumers wanted the latest model to make the Joneses green with envy, and planned obsolescence was born.

As GM's chief of design, Earl wandered through Selfridge Air Force Base in 1941, checking out the P-38 fighter planes. Perhaps he dreamed that one day cars-cum-hovercrafts would fly through the air and need the stability of fins for navigation. Regardless, Earl's inspiration was put on the back burner as World War II forced auto manufacturers to focus on vehicles of destruction. Only after the war would he go whole hog and base the 1948 Cadillac design on the Lockheed P-38 twin-engine fighter plane. The fins were both ridiculed and praised.

By the early fifties, styling was deemed more important than new engineering. Earl declared in 1954, "My primary purpose for twenty-eight years has been to lengthen and lower the American automobile, at times in reality and always at least in appearance. Why? Because my sense of proportion tells me that oblongs are more attractive than squares."

Other airplane-styling cues—from impractical wraparound windshields that warped vision to venti-port exhaust ducts on the sides of cars—were eventually discontinued. The wraparounds were abandoned because of safety, and the ducts "because a California high-school principal complained that some of his male students used those on his Buick to relieve themselves," David Gartman claims in *Auto Opium: A Social History of American Automobile Design*.

The battle of the fins and the swept-wing look began in earnest in 1957 with auto-industry claims that they were an essential element to stabilize larger cars. In reality, fins only steadied cars at speeds well over sixty miles per hour, and even then the aerodynamic effect was negligible. Unfortunately for civilians bent on escaping the ozone layer, Earl's designs offered more of the sound and fury of rockets than their actual substance.

Some consumers dared question the designers, as did Bishop Oxam in a 1958 issue of *Advertising Age*: "Who are the madmen who build cars so long they cannot be parked and are hard to turn at corners, vehicles with hideous tail fins, full of gadgets and covered with chrome, so low that an average human being has to crawl in the doors...?" By 1962, fins had mostly disappeared, and the flamboyance of the fifties was given up for the boxy designs of the sixties.

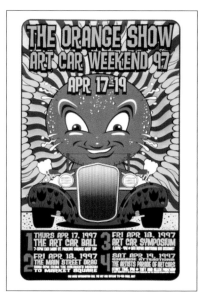

**Orange Show Art
Car Weekend** (above)
Inspired by an eccentric postman
who believed that oranges were the
key to healthy living, Houston art
car enthusiasts began an annual
parade of their offbeat vehicles.

Cadillac Ranch (left)
Here on the high plains of the Texas
Panhandle, ten Cadillacs are half
buried on the flat prairie to show off
the Jet Age styling of endless fins. As
in urban locations, graffiti covers the
permanently parked cars.
Courtesy of Eric Peterson

Saved by Fruit!

Postman Jeff McKissack thought that oranges were the ideal food that could save all humanity if we all just ate our fill. To spread the word on this juicy manna, McKissack gathered junk on his daily mail route and built a giant homage to the orange on the vacant lot across the street from his house in Houston, Texas. His original plan of a worm farm on the two lots was scrapped in place of this permanent propaganda for the perfect fruit. Now hundreds of visitors squeeze through the maze of corridors and can plunk down on a tractor seat to witness the bizarre collection of secondhand items McKissack gathered.

The eccentric mailman has since passed away, but the Orange Show Foundation keeps his dream alive in the annual Orange Show Weekend and Art Car Parade, attended by 200,000 spectators. The Orange Show Center for Visionary Art has evolved into a renowned clearinghouse for information on preserving folk-art sites and practices nationwide. McKissack would be proud.

Houston also has an Art Car Park, maintained by Ken Crimmins. An assortment of notable vehicles are parked behind chain-link fencing in the 1321 Milam garage, at the intersection of Pease and Travis, downtown.

Love Bug
The beloved Bug, the "folks' car," along with the Microbus, became a symbol of a peace-and-love subculture. This colorful VW is proudly displayed at Waldsee, the German Concordia Language Village, in Bemidji, Minnesota.

Motorists' Marvels

Outside of Alliance, Nebraska, Carhenge was created in 1982 by Jim Reinders. This faithful reproduction of Stonehenge is made out of thirty-eight monochromatic gray autos carefully placed in the same formation as the monoliths at the Druid site in England. Originally the townsfolk of Alliance were not pleased with this bizarre sight, telling Reinders he needed to apply for an expensive permit to operate a junkyard. Tourists detouring to the remote area specifically to see Carhenge changed their collective mind, and now the town embraces its claim to fame. Friends of Carhenge is the umbrella group that manages the site and funds its upkeep with bumper stickers and postcards.

Cars just might be the monoliths of our day, rusting away in enormous piles to baffle future archaeologists. Like Carhenge, temporary re-creations of Stonehenge were made out of junked cars for Australia's alternative and visionary 1990 ConFest by the Mutoid Waste Company. Cofounded by sculptor Joe Rush and Robin Cooke, Mutoid expounded Mad Max aesthetics that were part performance art, part installation, part radio-controlled junk sculpture originally created for raves in London. Rush also made a Carhenge at Glastonbury, the alleged site of King Arthur's Camelot. In addition to the UK Carhenge, Mutoid created Truck Henge, Tank Henge, and Plane Henge, taking their show on the road worldwide. In the United States, Survival Research Labs continues to put on traveling punk robot spectacles with their apocalyptic *Theater of Machines*.

Sculptors find the form of the auto endlessly malleable. In 2002 the Fleming Museum at the University of Vermont hosted a fabulous car-themed sculpture, *Volkswagenball*, by one of their alumni, Lars-Erik Fisk. Since 1996 he has created a series of large spheroid sculptures that refer to specific objects, buildings, and vehicles, such as *School Bus Ball*. The wheels aren't on the outside anymore, but the complete illusion that

a vehicle has been compacted into a perfect sphere is so amusing and somehow made plausible that the viewer feels compelled to get in and roll about.

Spindle, by Dustin Shuler, was a landmark sculpture in the Cermak shopping plaza in Berwyn, Illinois. Created in 1989, the forty-foot-high stack of eight skewered cars appeared in the movie *Wayne's World* and became a tourist attraction for the town. Like Carhenge, townspeople were initially divided over the sculpture's merits but warmed to its ability to garner attention for their city. Despite the Save the Spindle Society, the sculpture was dismantled on May 2, 2008.

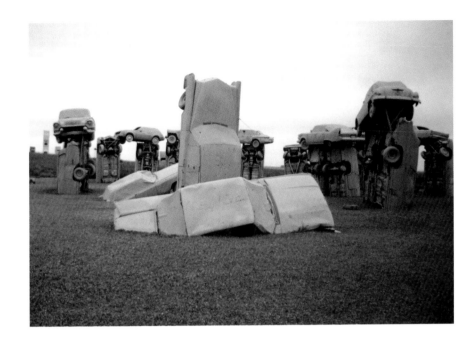

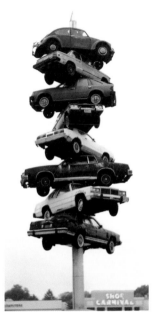

Carhenge (above)
Carhenge was created by Jim Reinders in 1982. A faithful reproduction of Stonehenge, thirty-three monochrome-gray-painted autos are carefully stacked in the same formation as the monoliths at the prehistoric site on the Salisbury Plain of England. Originally the town of Alliance was not pleased with the project, telling Reinders he'd need to apply for an expensive permit to operate a junkyard, but now tourists drive from around the country to see the American version of the pagan astronomical clock.

Green Gears at **Carhenge** (opposite page)
It's the duty of any art car owner to make a pilgrimage to the ultimate art car ruins, Carhenge, as coauthor Ruthann Godollei did in her *Volvo with Green Gears.*

Spindle by
Dustin Shuler (above)
A forty-foot-high stack of eight skewered cars appeared in the movie *Wayne's World* and the *Zippy the Pinhead* comic. The Car Kebab became a tourist attraction for Berwyn, Illinois.
Courtesy of Bart Longacre

In 1988, two years after the first art car parade in Houston, Texas, the first art car museum opened its doors. Longtime art car enthusiasts, authors, and curators Ann and James Harithas founded the Art Car Museum of Houston (aka Garage Mahal) to highlight not only art cars but also contemporary artists too outside the norm to have their work displayed in mainstream museums or galleries.

Prodigious art car creator and sculptor David Best was commissioned to decorate the exterior. Best created shiny machine-part and fuselage referents in chrome onion domes, like a Byzantine temple to the art car god reflecting the brilliance of the Texas sun. A lone green star above the covered carport is the beacon of solidarity for the imaginative and the adventurous.

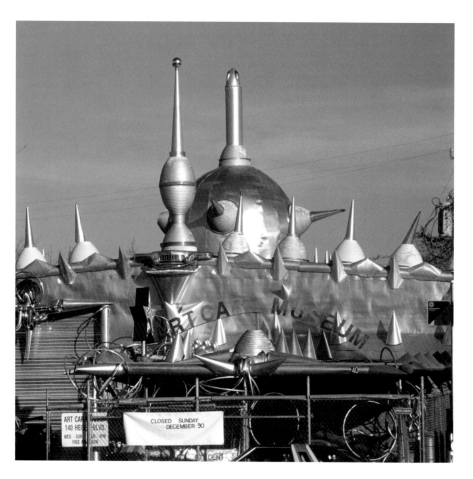

Art Car Museum (left)
Chromed car parts and a machine-themed façade by David Best, whose work is featured in the collection, make up the unique Art Car Museum. *Courtesy of the Art Car Museum*

Lotus Car at **Sudha Museum** (right, opposite page) Mr. Kanyaboyina Sudhakar, of Bahadurpura, Hyderabad, India, has his own car museum, featuring his numerous art cars, bikes, and novelty commercial vehicles. The lovely *Lotus Car* resides there, not to be confused with the British sports car of the same name. The lotus, the national flower of India, is associated with divinity and grace. *Courtesy of the Sudha Car Museum*

Wacky Car Museum

Kanyaboyina Sudhakar, of Bahadurpura, India, has his own Wacky Car Museum, featuring his numerous art cars, bikes, and novelty commercial vehicles. Included are the *Guinness Record Book World's Tallest Tricycle, Helmet Car, Condom Bike* (for raising AIDS awareness), *Football Car, Lotus Car,* and many more. *Tricycle* is forty-one feet, seven inches tall, and weighs about three tons, with a wheel diameter of seventeen feet. The titan trike has working pedals, chain, and sprockets, and took three years to build.

Hindu Shrine Cart

Vijayanagara, India, is the home of the ruins of Hampi, a UNESCO World Heritage Site containing the sixteenth-century Vittala temple. In front of the temple is a famous stone triumphal chariot carved from a single massive rock. Elaborate sacred carts, or rathas, were used to carry temple idols in holy processions. The shrine on wheels is dedicated to Garuda, the eagle mount of Vishnu in Hindu mythology. Eagles abound in the elaborate carvings.

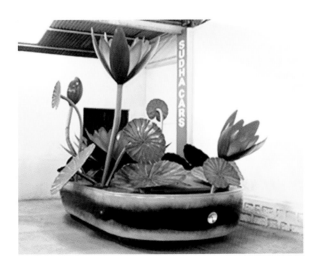

Vittala Temple Stone Chariot (right)
Sacred carts, or rathas, were used to carry temple idols in holy processions. The Vittala shrine on wheels is dedicated to Garuda, the eagle mount of Vishnu in Hindu mythology. Eagles abound in the elaborate sixteenth-century stone carvings.

Volkswagenball (above)
A feat of welding and bodywork, the perfect VW spheroid seems to welcome you to get inside and roll it about. First displayed at the Fleming Museum at the University of Vermont, Lars-Erik Fisk's sculpture is now in a private collection.
Courtesy of the Fleming Museum, University of Vermont

Recycled Aluminum Art (right)
Slim Sirnes wove thin strips of aluminum painstakingly cut from old soda cans into fanciful sculptures and functional objects such as lawn chairs, hats, belts, and purses. He also covered his truck and trailer with the material.

**Howard Finster,
Chattooga County, Georgia**
Howard Finster, the bicycle mechanic
turned world-famous folk artist, began
making art when God spoke to him
via a drip of green paint. He made
more than one art car, and when
they wore out, he incorporated the
carcasses into Paradise Gardens.

"The car is so much more than a means
of transportation: it is a locus of intense
emotional activity. Within its confines
lives are lived. It can offer solitude from
telephone, kids, and colleagues; it is the only
place many of us find ourselves alone."

—Judith Hoos Fox, in *Inside Cars*

Shrine in Progress

Formed as a nonprofit endeavor in 2006, Art Car World, located in the border town of Douglas, Arizona, is "a museum dedicated entirely to the celebration and preservation of this popular mobile art form." Harrod Blank saw the need to give his own and other art cars a home other than the junkyard. Fellow ArtCar Fest cofounder Philo Northrup is on the board of directors. Art Car World permanently preserves many art car classics, such as Emily Duffy's *Mondrian Car* and *Carthedral* by Rebecca Caldwell.

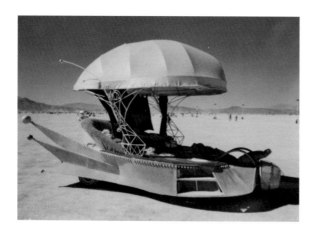

Visitation
Only art cars are allowed to drive the rounds at the Burning Man festival in Black Rock City, Nevada. Visitors must clean up scrupulously after the event's end so no trace of the festival is left. Tom Kennedy's car, *Visitation*, is ready to beam up from the desert floor. *Courtesy of Tom Kennedy*

Desert Destinations

Burning Man is a free-expression festival held annually in Nevada's Black Rock Desert. Art car artist Michael Mikel (aka Danger Ranger) joined the project in 1990 and is a member of the executive committee. At this festival, having an art car has its privileges. Ordinary cars are not permitted on the playa; only vehicles like Tom Kennedy's car *Visitation*, which looks like it could beam up from the desert floor, are allowed. "Your car must be approved by our Department of Mutant Vehicles and you must have a DMV sticker in order to drive it," warns the Burning Man literature. During eight days in late summer, a temporary town rises on desert sand and participants create camps, art, happenings, and attractions, bringing that year's theme to life. Burning a giant effigy is the culminating event of the festival. This practice, with its connotations of renewal and rebirth, has its roots in pagan England. Visitors are asked to clean up scrupulously at the event's end so no trace of the festival is left. This is proving more challenging as attendance has reached 40,000 in recent years.

More permanent desert art car attractions can be found in Nevada, such as the menacing *VW Bug Spider* by artist David Fambrough and Slim Sirnes's Goldfield Art Car Park, which features cars from the estate of the late Robert VanKeuren III (aka Rockette Bob), as well as Slim's fabulous recycled woven aluminum art, including his truck.

The art cars of the future are being built as prototypes today. Many engineering schools at large universities have made experimental vehicles that run only on solar energy. A World Solar Rally was held in Taiwan in 2006 with top-cars clocking in at 100 miles per hour. In the United States, solar-car races are held on the burning sands of the Bonneville Salt Flats in northwestern Utah to maximize access to the sun and minimize detrimental weather factors. The odd shapes of the solar rollers—super thin and low to the ground but wide and flat on top—are dictated by the need to maximize surface area for solar rays and minimize weight and wind resistance.

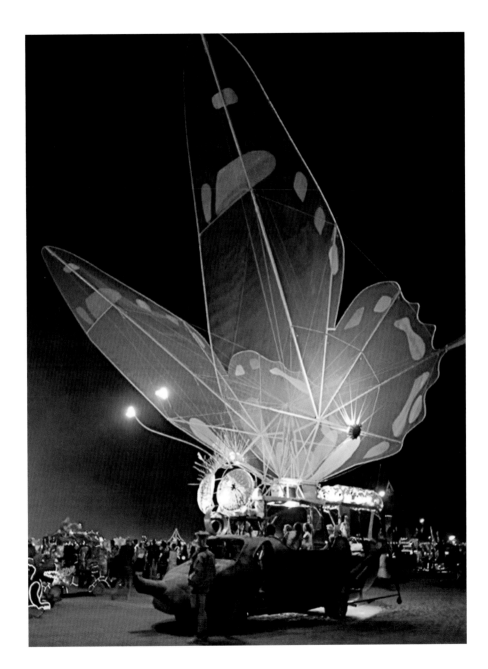

Lepidodgera
Rachael Norman, Mike Thielvoldt, and Jake Haskell created this thirty-seven-foot-tall steel butterfly perched atop a Dodge van. The 6,000-square-foot wings move by hydraulic action and are brilliantly illuminated at night. Its onboard gasifier converts biomass into fuel. *Courtesy of Ryan Jesena*

Coming Attractions!

Fine artists can sidestep the gallery system by taking their art to the streets. If your artwork isn't in vogue, has political import, or is just too strange to easily market, putting it on display where the maximum amount of viewers will see it is a viable alternative. Beginning in the late 1980s, the art car movement boomed as an alternative to blue-chip galleries, which saw art as an investment. Art car artists can choose when and where to show their work, the length of the exhibit, and which cities it will hit on tour. St. Louis artist Lisa Bulawsky devised Blindspot Galleries, a mobile host for temporary exhibits printed on vinyl magnetic sheets clinging to her white Ford minivan. Until 2005 she curated shows and invited guest artists for monthlong stints on display wherever she happened to drive.

Performance artist Julie An O'Baughill (aka JAO) created the JAO ArtMobile, or the Speed Painting Truck, containing a platform with canvas or paper rolls and all the supplies to make a painting in under three minutes. She dons a helmet, knee pads, heart-rate monitor, and whistle and frantically paints oversized screaming expressionistic figures to rousing music, such as the

William Tell Overture. "I am an artist and an athlete," she proclaims. "My process is to increase my heart rate through aerobic activity and then paint. My theory is that a stimulated sympathetic nervous system increases focus and aids in creative decision making. I call this speed painting." She continues to perform annually at an impressive schedule of venues across the country.

Some art car attractions come to your door, in the form of traveling displays. Like the itinerant snake-oil shows of old, the FunOMENA Mobile Museum by Gerry Ann Siwek exhibits a healing chair, a weeping icon, crop circles, plant oddities, and more. Based in Regina, Saskatchewan, her trailer travels extensively to fairs and festivals, including many art car gatherings. Customs inspections have proven quite challenging, since the caravan boasts "Live Exhibits of the Weird and Strange."

For Nebraskan Don Robertson, the destination is the ride. His *Route 6 NE* car is an homage to the state's oldest highway, which stretches from east to west for 374 miles. The car was sponsored for a while by Nebraska's Division of

Travel & Tourism, which called the highway the "pathway to leisurely adventure." Midwesterners would come up to the car and point out where they came from along the map of the interstate stretching the length of the car. On more than one occasion, *Route 6 NE* has been joined by other art cars for a Route 6 Nebraska tour, billed as the World's Longest Art Car Parade.

Erika Nelson of Lucas, Kansas, is the creator and curator of the World's Largest Collection of the World's Smallest Versions of the World's Largest Things Traveling Roadside Attraction and Museum. She describes herself as a nomadic volunteer, traveling to towns and viewing the world's largest things (those cement and plaster colossi: giant buffalo, humongous chickens, magnified muskies, oversized otters, biggest balls of twine, etc.) and other roadside attractions, documenting them and making miniature models to put in her mobile museum. It is very amusing to see a tiny doll of Paul Bunyan when you know that in Bemidji, Minnesota, as in legend, he is really, really big. Nelson writes a newsletter and gives lectures, tours, and educational workshops about the world's largest things, noting how they interact with and build community in unique ways. Her museum is like a bookmobile, where viewers browse for favorites among things they know and can inquire about the unfamiliar. Its institutional mission, as is that of all art cars, is to "fight generica."

Mobile Museum of Buddhist Art
(left, opposite page)
Art historian Todd Rowan parked his Mobile Museum of Buddhist Art outside the Weisman Art Museum. The car hosts miniature shrines, temples, and eight pairs of tiny blue arms giving a gesture of blessing.

FunOMENA Mobile Museum
(right, opposite page)
Based in Regina, Saskatchewan, Gerry Ann Siwek's FunOMENA traveled south of the border to Wheels as Art to show off a healing chair, crop circles, and other unexplained paranormal activities. Stops at Customs proved challenging. *Courtesy of Alan Davidson*

Route 6, Nebraska **Detail by Don Robertson** (above)
Sometimes the destination is the ride, as shown on Don Robertson's long and winding road mobile. The *Route 6, NE* car was an homage to the state's oldest highway, which stretches from east to west for 374 miles.

**World's Largest Collection of the World's Smallest Versions
of the World's Largest Things Traveling Roadside Attraction and Museum**
Erika Nelson of Lucas, Kansas, is the creator and curator of this mobile museum. It contains miniature models of famous cement and plaster colossi: giant buffalo, humongous chickens, biggest balls of twine, Paul Bunyans, and other roadside attractions. Its mission is to "fight generica." *Courtesy of Erika Nelson*

A Moveable Feast, 1930
A mini, mobile version of South Dakota's Corn Palace showed off the fruit of the land with dangling beets, dill, and potatoes at a 1930 Farm Bureau Picnic Parade. Grass and produce cars took part in the earliest midwestern car parades, celebrating hearty pioneer sodbusters and farmers' bounty. *Courtesy of the Minnesota Historical Society*

ABOUT THE AUTHORS

Eric Dregni

Eric Dregni has obsessions ranging from futuristic jet packs to oversized fiberglass town monuments to Zamboni ice resurfacers. He's turned his fixations into thirteen books including *Follies of Science: 20th Century Visions of our Fantastic Future, Weird Minnesota, Midwest Marvels, The Scooter Bible, Ads That Put America on Wheels,* and *Let's Go Bowling!*

Dregni worked in Italy for five years as a travel journalist for a weekly paper and compiled his essays into a book in Italian: *Never Trust a Thin Cook: and Other Lessons from Italy's Culinary Capital.* As a Fulbright fellow to Norway, he survived a dinner of *rakfisk* (fermented fish) thanks to eighty-proof aquavit, took the "meat bus" to Sweden for cheap salami with a busload of knitting pensioners, and compiled the stories in *In Cod We Trust: Living the Norwegian Dream.*

In the summer, Dregni runs the Italian Concordia Language Village, Lago del Bosco. He lives in Minneapolis and teaches writing and journalism at Concordia University where he is an assistant professor of English.

Ruthann Godollei

Ruthann Godollei, a professor of art at Macalester College in St. Paul, Minnesota, teaches printmaking, design, and art theory. Working primarily in the media of prints and drawings, she incorporates political and social commentary in pieces with ironic humor. Godollei has research interests in print history, cultural studies, and art cars. She has participated in, sponsored, and organized art car events since 1984. At the age of ten, she hand stenciled tiger stripes on her vintage Monarch bicycle. She is a founding member of the annual Art Cars on Ice caravan, the world's only art car parade across a frozen lake. She has given hundreds of public lectures on art cars, from the Bratislava Academy of Fine Art to the Menil Collection in Houston. The daily driver of a 1985 Volvo covered with thousands of printed green gears, she calls her custom stencil process "Godolleization."

Godollei's work is in many collections, such as the Belgian Royal Museum of Art, the Polish National Museum of Art, KUMU; the Estonian National Fine Art Museum in Tallinn, the Croatian National University Library, the Minnesota Historical Society, Syracuse University, Rutgers University, and the Frederick R. Weisman Museum in Minneapolis.

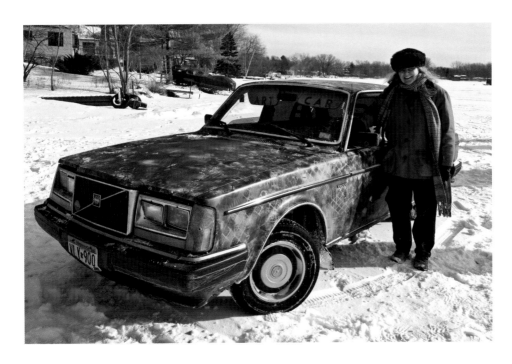

APPENDIX

Web Resources

Aerocar by Dave Major: new.photos.yahoo.com/aerocar
Art Car Agency: artcaragency.com
Art Car Events Calendar: artcarcalendar.com
Art Cars in Cyberspace: artcars.com
Art Car Nation, web resource for art car lovers: artcarnation.ning.com
Art Car Society of Canada: gypsymermaid.com/asc.html
ARTCARS, Directory: geocities.com/artcars/events.html
artcarz: groups.yahoo.com/group/artcarz
Banana Bike Brigade: bananabikebrigade.com
BMW Painted Car Gallery: bmwworld.com/artcars/index.htm
Eccentric America: eccentricamerica.com/index.htm
Ed "Big Daddy" Roth: ratfink.org
Green Woman Art Cars: www.shelleybuschur.com
Houston Art Car Klub: houstonartcarklub.com
JAO Speed Painting: jaoart.com/performance.shtml
Lepidodgera: lepidodgera.com
MARV, Minnesota's ARt-Vehicles: artcarparade.com/marvorama.html
Reader's Digest: rd.com/content/cars-decorated-as-art
Rick McKinney: jigglebox.com/writer.html
Rocket Van: rocketvan.com/artcar/artcar_search.php
The Seattle Art Cars: seattleartcars.org
Survival Research Labs: srl.org
Wooden Cars at a Woody Car Site: oldwoodies.com/gallery-weird.htm
Wooden Cars by Livio de Marchi: liviodemarchi.com/largeworks.htm
World's Tallest Trike, Sudha Museum: indiavrtours.com/hyderabad/index.html

Events and Parades

ArtCar Fest
San Francisco, CA: artcarfest.com

Art Cars on Ice
Medicine Lake, MN: artcarparade.com

The ArtCar Parade
Minneapolis, MN: artcarparade.com

Art Car Weekend
Houston, TX: orangeshow.org

Art on Wheels Parade
Prescott, AZ: zenzibar.com/artonwheels.htm

ARTrageous Parade
Eureka Springs, AR: eurekaspringsartcar.com/info.html

Artscape Baltimore
Baltimore, MD: artscape.org/index.cfm

Art Tougeau Parade
Lawrence, KS: arttougeau.org

Austin Art Car Parade
Austin, TX: austinartcar.com

Baton Rouge Art Car Parade
Baton Rouge, LA: artcarbr.com

Burning Man
Black Rock City, NV: burningman.com

Cartopia
Berwyn, IL: berwyncartopia.com

The Central Art Car Exhibit & Celebration
Omaha, NE: artcarparade.com/CACE.html

Charles Village Parade
Baltimore, MD: charlesvillage.net/festivalcalendar.html

Chiditarod Urban Iditarod
Chicago, IL: chiditarod.org

Cornerstone Sacred Art Car Parade
Bushnell, IL: cornerstonefestival.com

Funky Art Car Festival
Vancouver, BC: gypsymermaid.com

Grand Old Day Parade
St. Paul, MN: grandave.com/grandoldday

Guerilla Artcar Drive-In
Portland, OR: skatingonthinice12@yahoo.com

Kentucky Art Car Weekend
Louisville, KY: kentuckyartcarweekend.com

Kinetic Art Parade
Columbia, MD: columbiafestival.com/kineticArt.html

The King Wamba Carnival Parade
Toledo, OH: odelot.org

Maker Faire
San Mateo, CA: makerfaire.com

Mount Dora Art Car Weekend
Mount Dora, FL: www.mtdoraartcars.com

Route 6 Nebraska Tour
NE: route6nebraska.com/news.asp

Seattle Art Car Blowout
Seattle, WA: seattleartcars.org/wazup.html

Transformus, Arts, Gifts, & Music Festival
Deerfields, NC: transformus.com/art/DMA.html

Tulsa ArtCar Weekend
Tulsa, OK: livingarts.org/artcar.htm

The UK's First Art Car Parade
Manchester City Centre

World Art Car Day, Nov. 14
Worldwide

Museums and Parks

American Visionary Art Museum
800 Key Hwy,. Baltimore, MD 21230: avam.org/artcar

The Art Car Museum
140 Heights Blvd., Houston, TX 77007: artcarmuseum.com
713-861-5526

Art Car Park
1321 Milam St., Houston, TX 77006

Art Car World
450 East 8th St., Douglas, AZ 85607: artcarworld.org

BALTIC Centre for Contemporary Art
Gateshead Quays, South Shore Rd., Gateshead NE8 3BA, United
Kingdom: balticmill.com

Carhenge
2141 County Rd. 59, Alliance, NE 69301: carhenge.com/

Circus World Museum
550 Water St. (Hwy. 113), Baraboo, WI 53913: wisconsinhistory.
org/circusworld

DAF Museum
Tongelresestraat 27, 5613 DA, Eindhoven, The Netherlands

Goldfield Art Car Park
Hwy. 95, Goldfield, NV 89013

Le Musée des Carrosses (Carriage Museum)
Palace of Versailles, France: chateauversailles.fr/en/141_The_Stables

Museo del Carretto Siciliano
Terrasini, Province of Palermo

National Automobile Museum The Harrah Collection
10 South Lake St., Reno, NV 89501: automuseum.org

National Automobile Museum The Louwman Collection
Steurweg 8, 4941 Raamsdonksveer, The Netherlands:
louwmancollection.nl

Paradise Gardens
Summerville, GA 30747: finster.com

Petersen Automotive Museum
6060 Wilshire Blvd., Los Angeles, CA 90036: petersen.org

Sicilian Etnografico Museum Giuseppe Pietrè
Via Duca of the Abruzzi, 1, Palermo, Italy: museopietre@tin.it

Sudha Cars Museum
19-5-15/1/D, Bahadurpura, Hyderabad, India: sudhacars.net

Wienermobile
kraftfoods.com/om/omm_virtualtour.htm

The World's Largest Collection of the World's Smallest Versions of the World's Largest Things Traveling Roadside Attraction & Museum
WorldsLargestThings.com

BIBLIOGRAPHY

Artaud, Antonin. *Selections.* Los Angeles: Panjandrum Books, 1982.

Barnard, Malcolm. *Art, Design and Visual Culture.* New York: St. Martin's Press, 1998.

Barnes, Richard. *Mods!* London: Eel Pie Publishing, 1979.

Barthes, Roland. *Mythologies.* New York: Hill & Wang, 1972.

Baudrillard, Jean. *The System of Objects.* London: Verso, 1968.

Baum, L. Frank. *The Marvelous Land of Oz.* New York: Books of Wonder, William Morrow & Co, 1904.

Bayley, Stephen. *Sex, Drink & Fast Cars.* New York: Pantheon Books, 1986.

Blank, Harrod. *Wild Wheels.* San Francisco: Pomegranate Art Books, 1994.

———. *Art Cars: The Cars, the Artists, the Obsession, the Craft.* New York: Lark Books, 2002.

———. *Automorphosis.* Documentary Film. Berkeley: Blank Films, 2007.

Burgess-Wise, David. *Automobile Archaeology.* Cambridge: Patrick Stephens, 1981.

DeBord, Guy. *The Society of the Spectacle.* New York: Zone Books, 1967.

de Certeau, Michel, et al. *The Practice of Everyday Life.* Vol. 2, *Living & Cooking.* Minneapolis: Univ. of Minnesota Press, 1998.

Dregni, Eric, and Karl Hagstrom Miller. *Ads That Put America On Wheels.* Osceola, WI: Motorbooks International, 1996.

Dregni, Michael, and Eric Dregni. *The Scooter Bible.* Center Conway, NH: Whitehorse Press, 2005.

Ewen, Stuart. *All Consuming Images: The Politics of Style in Contemporary Culture.* New York: Perseus Books, 1999.

Flink, James J. *The Automobile Age.* Cambridge: MIT Press, 1988.

Fox, Charles Philip. *America's Great Circus Parade.* Greendale, WI: Reiman Publications, 1993.

Gramsci, Antonio. *Prison Notebooks.* "Americanism and Fordism." Translated from *Lettere dal carcere.* New York: Harper & Row reprint 1973, 1934.

Gronberg, Tag. *Designs on Modernity.* Manchester: Manchester Univ. Press, 1998.

Guggenheim Museum. *The Art of the Motorcycle.* New York: Guggenheim Museum Publications, 1998.

Harithas, Ann. *Art Cars, Revolutionary Movement.* Houston: Ineri Foundation, 1997.

Harris, Moira F. *Art on the Road: Painted Vehicles of the Americas.* St. Paul: Pogo Press, 1988.

Hawley, Henry H. *Bugatti.* Seattle: Univ. of Washington Press, 1999.

Hebdige, Dick. "Object as Image: the Italian Scooter Cycle." *Hiding in the Light.* London: Routledge, 1988.

Hultén, K. G. Pontus. *The Machine, as Seen at the Mechanical Age.* New York: The Museum of Modern Art, 1968.

Jewell, Derek, ed. *Man & Motor: the 20th Century Love Affair.* New York: Walker & Co., 1967.

Jhally, Sut. "The Fetishism of Commodities." *The Codes of Advertising: Fetishism and the Political Economy of Meaning in Consumer Society.* New York: Routledge, 1990.

Joans, Barbara. *Bike Lust: Harleys, Women, and American Society.* Madison: Univ. of Wisconsin Press, 2001.

Kahn, Douglas, ed. *Cultures in Contention.* Seattle: Real Comet Press, 1985.

Kurth, Willi. *The Complete Woodcuts of Albrecht Dürer.* New York: Dover, 1927.

McDonald-Walker, Suzanne. *Bikers: Culture, Politics and Power.* Oxford: Berg, 2000.

McShane, Clay. *Down the Asphalt Path: The Automobile and the American City.* New York: Columbia Univ. Press, 1994.

Piggott, Stuart. *The Earliest Wheeled Transport.* New York: Cornell Univ. Press, 1983.

INDEX

Rawlings, Terry, and Keith Badman. *Empire Made: The Handy Parka Pocket Guide to All Things Mod!* London: Complete Music Publications, 1997.

Shuler, Terry. *The Origin and Evolution of the VW Beetle*. Princeton: Automobile Quarterly, 1985.

Tarr, Patsy, ed. *Inside Cars*. New York: Princeton Architectural Press, 2001.

Thompson, Hunter S. *Hell's Angels*. New York: Ballantine, 1966.

———. "Song of the Sausage Creature." *Cycle World*, March 1995.

Veblen, Thorsten. *The Theory of the Leisure Class*. New York: Penguin Books, 1994.

Wernick, Andrew. "Vehicles for Myth: The Shifting Image of the Modern Car" in *Cultural Politics in Contemporary America*. New York: Routledge, 1989.

Williamson, Judith. *Decoding Advertisements*. London: Marion Boyars, 1978.

Wolfe, Tom. *The Kandy-Kolored Tangerine-Flake Streamline Baby*. New York: Noonday Press, 1965.

Wright, Frank Lloyd. *Truth Against the World*. Washington, DC: Preservation Press, 1992.

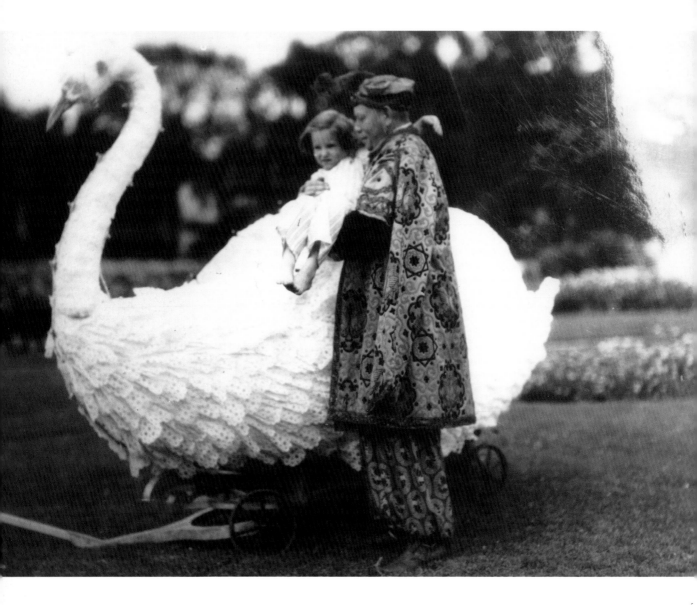

Swan Cart, 1936

As part of a 1936 Dream Parade, a lovely swan wagon was pulled along as kids took turns riding in the fairy-tale scene. *Courtesy of the Minnesota Historical Society*